I Knew I Was a Woman When...

Defining Female Moments: What's Yours?

Vanessa Denha

The "SitChat" Series

PublishAmerica
Baltimore

First printing

ISBN: 1-4137-0708-4
PUBLISHED BY
PUBLISHAMERICA, LLLP.
www.publishamerica.com
Baltimore

Printed in the United States of America

To my dad, Sabri Mansour Denha,
who taught me to be the best "woman" I can be.

Clair
To one of
my favorite Sumo
cousins. We hope
you enjoy the
read! Vanessa

Acknowledgements

Thank You...

I couldn't decide whom to thank first because there are so many people who helped me along the way. I decided to start from the beginning.

Jennifer Harrison-Stang is not only a close friend and a respected colleague, but she is also an excellent editor. I thank her for her skill and expertise, and for being the first person who not only encouraged me but also offered suggestions and ideas that helped fine-tune this book.

My sister, Veronica, who was surfing the web one day, came across a web page for the Maui Writer's Conference. She printed the information out and told me to go. Ironically, I came across an advertisement for it in *Writer's Digest* and, that same week, I interviewed C. Leslie Charles, author of *Why Is Everyone So Cranky?*

I ended up chatting with Leslie after our half-hour interview and she said the Maui Writer's Conference was one of the best investments in her career. Okay, how many signs do I need? A few weeks later, I booked my trip and begged Veronica to tag along for moral support. I didn't have to beg very long. I thank Leslie and Veronica for their encouragement.

I already had the idea for this book, which I had been working on for more than a year, but I didn't know much about the publishing business. I thank the founders and participants

of the Maui Writer's Conference. It catapulted my career to the next level.

At the conference, I met one of the most important influences in my writing career, Sam Horn. I call her my muse—yes, a real live muse. She is really a consultant and a genius, at that. She is also a professional speaker who has published several books. I thank her for her insight and endorsement of this book.

At the conference, I met many amazing and talented people. I had the opportunity to talk with Colleen McKenna, children's book author, among others. She sat with me one afternoon during a break and brainstormed with me. I thank her for her time, honesty and interest in my project. Lisa Delman, another writer I met at the conference, graciously accepted my request for writing my foreword—one that touched my soul. Thanks Lisa.

Then, there were people in my everyday life who told me that this would be great. Writing is sometimes a tedious and grueling task, and without friends and family giving me daily doses of love and praise, I might have turned off my computer forever without working on this chapter in my life. I thank my biggest supporter and best friend, Ron Garmo, for encouraging me to finish the book.

I thank my mother and six sisters.

Thanks to Mom for her ability to overcome obstacles and survive, and who, in many ways, influenced my journey into womanhood. Thanks to my sister Sandra for her moral support, Suzanne for her bragging rights, Sally for her belief in me, Stephanie for her excitement, Veronica for putting up with all my sometimes extremely annoying habits and to Shanna, my youngest sister, who loves to bask in the success of her older sisters. Thanks, also, to my aunt Jaclyn for her proofreading ability and fair critique of the project.

What would a girl do without friends? Jennifer Thomas Abbo, my oldest and dearest friend, a pure spirit. I thank her

for all the mornings we spent on the phone, while I drank my coffee and expressed my fears and frustrations about this project. I also thank her for proofreading my book. Jennifer Antone also lent her editing skills to this project—thanks for being such a true friend.

Many of my loyal friends served as proofreaders. I am fortunate to be close to women with an eye for detail. These women spent their free time going over my book and commenting on the content. Thanks to Julie Garmo, Rhonda Barno, Renee Denha and, again, my sister Veronica.

The point of this book is to start women on a journey into meaningful dialogue. I wanted to create a new type of group for women called a "SitChat"®. I interviewed some of the women in this book at already existing groups: I thank The Barbara Ann Karmanos Cancer Institute in Detroit, Michigan, and the women in William Beaumont Hospital's breast cancer support group for allowing me to lead one of my first "SitChats." I thank Maria for inviting me into her home for one of her weekly "Mommy and Me" days.

Theresa Falzone, an editor whom I have worked with for several years, got her book club women involved in my book and told me that, as a writer, I should stop trying to fit a circle into a square-shaped opening.

Thanks to my publishers and editors at PublishAmerica for their patience while waiting for me to finish this manuscript. I thank Attorneys Mike Novak and Randall Denha for their expertise.

And to all the women in this book who were open, honest and courageous. I thank them for sharing their stories with me.

Thanks, also, to all the people with humor and wisdom whom I have quoted throughout this book. For the quotes with the "Author Unknown" tags, I apologize for not knowing the names but would be happy to add them if I knew who uttered the words.

I am grateful for the World Wide Web and the authors of the

many websites I perused while writing this book and searching for information. I have credited all books, magazines, television shows, networks and websites throughout the book when it was possible. For some of the information I found, I wasn't able to find the original authors or articles.

I thank you—the reader—for picking up this book. I am excited for you and the journey you are now taking. I hope you are moved and encouraged to elevate yourself to a higher level and to create your own "SitChat"!

Please visit my website at www.vanessadenha.com and share with me your experiences. I would also encourage feedback about the book.

Foreword

Vanessa's words sing beautifully in my ears and bring tears to my eyes. "What was the moment you felt like you had become a woman?" As I contemplate the most important question of my life, I want to simultaneously hide under my sheets, jump up for joy, cry hysterically, and passionately dance in the street. It is by far one of the most universal and profound questions a woman can ask herself. These sacred words have us travel deep within our soul for the defining moments of our lives that transform us from childhood to womanhood.

I Knew I Was a Women When... my mother lay in a coma with only a 20% chance to live. Suddenly faced with her possible departure, I reached a new level of understanding and tenderness within myself. I viewed my mother and our relationship from a new perspective. I understood that many of the issues I resented her for were more about me than her. I began to empathize with her as a woman, not just as a mother. I saw so much of myself within her. As I embraced her challenges and triumphs in a compassionate way, I was graciously able to accept my own humanity. At that crucial moment, I became a woman.

As I wander back to my childhood, I remember crying endlessly about boys, and feeling that I was not pretty enough, or smart enough to belong to the "in crowd." As we reminisce in our past as girls, we can all remember the uncomfortable

9

years of racing hormones, and the conflicting cultural messages from our peers, teachers, families and advertisements of what a woman should be. Suddenly, as if overnight, we are desperately trying to find our destination in the world. Finally, Vanessa's book, *I Knew I Was a Woman When...* takes us on a voyage to the divine place within.

Why is it crucial to ask ourselves what Vanessa asks of herself about the defining moments of womanhood? It challenges us to search beyond the expectations we were born into, travel our childhood for the answers that sculpt us as women today, and embrace ourselves with sacredness and beauty. Redefining our womanhood to shape our needs and wants is what we thirst for, and what "living our truth" is all about. As Nelson Mandela so beautifully states in his inaugural speech, "As we let our own Light shine, we unconsciously give other people permission to do the same. As we are liberated from our own fear, our presence automatically liberates others."

I Knew I Was a Woman When... speaks of a yearning that all women have. It relieves us of unnecessary burden from the past and frees us to fly on our own path. Vanessa clearly teaches through women's stories and commentary to celebrate our birthright with enthusiasm and love. Although our journeys are varied, womanhood is what intricately bonds us together. "What was the moment you felt like you had become a woman?" The answers lie within the pages of your heart.

Truly,
Lisa R. Delman
Letters From the Heart Project
"Connecting the Hearts of the World"
Author of *Dear Mom, I Want You to Know...*, Putnam 2005

Am I a Woman Yet?

May I ask you a question that haunts my soul?
Am I a woman yet?
Because I still do not feel whole.

When did my journey begin?
Was it marked with a time and place?
The day nature took its course, or when life became too hard to face?

I think I missed it, somewhere along the way.
Or perhaps I haven't found it yet, because I still have a price to pay.

Does it come with guilt, pain and sorrow?
When your innocence is gone and you're desperate for tomorrow?

Is it the first touch of a man?
He caresses your body, fills you with love but leaves you melancholy?

Or, perhaps when I bear a child I will feel complete?
I will have made my mark, and left behind will be a part of me.

I stand at the highest hilltop shouting to the skies:
Why haven't I been told the secret?
Is my life just one big lie?

As I begged for the answer, an angel whispered in my ear:
A true woman understands her own tears.

It isn't defined by nature.
Or set by a time and place.
A girl becomes a woman at her own pace.

It is individuality and trust in oneself.
It is compassion for mankind, but, most of all,
it is love for oneself!

– Vanessa Denha

Introduction

Why This Book...

It was spring of 1999. I was driving on the Lodge Freeway passing through Southfield, Michigan, on my way home from work—home is a suburb 30 miles north of Detroit—when the same question I had been pondering for weeks just seemed to block my vision.

It was as if someone taped a sign on my window that read: Am I a woman yet? I know, it sounds like a silly question; I'm almost embarrassed to type it on this page. But think about it: Do you truly feel like a woman? Why or why not?

I've turned 18 years old. I can vote. I graduated from college. I'm older than 21 and of the legal age to drink. I've fallen in love. I've bought my own car. I'm an adult, right? Not necessarily.

Even at the age of 25, I still didn't feel like a woman, yet all the signs pointed to the fact that I was. I'd gone through puberty, outgrown my training bra, experienced love and loss. I looked like a woman and society would depict me as one by the mere fact I had reached the age considered a "legal adult." Still, for some reason, I didn't believe I was truly an adult.

This haunted me. There I was in my mid-20s, a journalist and unhappy because I was confused. I felt like this pick-tailed girl sitting on Daddy's lap, although I started to mature at 12 and had a Dolly Parton figure before I turned 20.

I thought there should be some defining moment and I

13

would know I had become a woman. But, I had no idea. So I set out on a quest to find out how different people define womanhood—not just being an adult, but being a woman in today's society.

As a journalist, the first thing I do when I don't know the meaning of a word is look it up in the dictionary. When I got home that day, I grabbed my red hard-covered *Webster's Encyclopedia Unabridged Dictionary of the English Language*.

Yes, I knew the meaning of being an adult and a woman, but why didn't I feel like I fit the definition? I wanted some confirmation.

Definition of an adult: "Having attained full size and strength; grown up; mature: an adult person, animal or plant."

Definition of a woman: "The female human being (distinguished from the man)."

Okay. There it was in black and white. It only confirmed what I already knew. So, my research continued. I searched the web.

"Adulthood is not defined as passage through traditional events and physical changes in the body, but rather a change of your personality and behavior." That's according to British researcher Fiona Ulph of Southampton University in Highfield.

After 1,300 men and women filled out a questionnaire, Ulph discovered that traditional indicators of adulthood—like marriage or getting a job—were of little importance to the participants she questioned. Instead, characteristics, which fostered individualism, played a more significant role in defining adulthood.

She interviewed people ranging in age from 16 to 30, and based on her information, those people identified five measures of adulthood:

- Accepting responsibility for the consequences of actions
- Deciding on personal beliefs and values independently of parents or other influences
- Achieving financial independence from parents
- Becoming less self-oriented, and developing greater consideration for others
- Avoiding drunk driving

At the time of her research, Ulph indicated that further study needs to be done, but she concluded that personality characteristics appear to have displaced specific life events as telltale signs that adulthood has arrived.

When I read the article written about Ulph's research, I e-mailed her about my book. She kindly responded but was modest when I complimented her on her work. She said there has been years of research done on the subject and I might want to keep looking for other researchers.

After reading her article, I believed that I was getting somewhere. I fit the dictionary's definition and understood Ulph's theory. But, for the purpose of this book, I wanted to focus on being a woman more than just becoming an adult.

Defining adulthood is one thing, but defining womanhood is quite another. Perhaps for some people, it is one in the same; the day you felt like an adult is the same day you emerged from little girl to woman. But, how many of us truly define ourselves instead of allowing outside influences to define who we are—as women?

My sister Sally once said that life became complicated when she realized she had so many choices but the realization also set her free. The women who walked before us liberated us and now we can choose what we want to do: get married, have children, have a career—whatever.

I thought about what she said for years. Maybe we have a difficult time defining womanhood because women today play

so many roles and we are not sure if we define the roles or if they define us.

I wear many hats. Yes, it's an old cliché but it's really the only way to explain my life. I am a woman of many roles. And I'm going to take liberty in revising another cliché and say that, as a journalist, I am an expert at everything and a professional at nothing.

But I am so much more than that. Aren't we all? Instead of being defined by the roles we play, why not define the roles to fit who we are? Professionally, I was a reporter, broadcaster, writer, speaker and media expert.

Currently, I have replaced the reporter role for a press position with a local elected official, but professionally I continue doing the other work. I am also a daughter, a sister, an aunt, a friend and most of all a child of God. I have been someone's girlfriend and often felt like the mother figure to other people's children—and to a few of the men I have dated.

Over the years, I have asked myself many questions that almost doubt who I am and the decisions I have made in my life. We do this daily. Not long ago, when my alarm would buzz at 4:00 a.m. every morning, I would ask myself why I decided to pursue a career in radio. My day actually started out with me doubting a major decision in my life. I have many years vested in this career, yet I am still waiting to see the rewards.

And the questions continue. Sometimes a dozen are asked in the course of a day: I wonder if I should get my master's degree or if I want children. I didn't know if I would get married and if getting married and having children will mark the day of womanhood for me. I used to think if I do get married, what kind of marriage I want. Am I outgrowing some of my friends? I often think about pursuing a different career, how I should ask for a raise or if I should go into business for myself.

Whenever the opportunity would arise, I would ask women

the same question I asked myself on that drive home. Some of the answers are included in this book, others I just kept to myself. But from each woman I learned something new. This thirst for truth and meaning became my mission. It was more than just completing a book. It was about self-discovery. I also wanted to know what other people had to say. Every time I conducted an interview on either of my two weekly talk shows, I somehow included this topic in conversation.

One of my favorite authors, Dr. Wayne Dyer, once told me on my show "Secrets to Good Health" on WJR 760 AM in Detroit that we have thousands of thoughts a day and many of those are negative. He went on to explain that we actually become what we think about, even the very thing we despise. How do we become the confident woman I wanted to be? I could start thinking like her.

Think about the questions we ask ourselves every day.

And for many of you the questions may be more complex than the one I pose to myself. You might ask: Why am I unhappily married? Should I get a divorce? How do I let go of my children? How do I salvage my marriage? Why did I get married? Why am I not married yet? Then the questions become jumbled in your head like a jigsaw puzzle in an unopened box.

The outcome of our lives is based on the decisions we make today. Every action has a consequence, and from that we define ourselves. How we answer the above questions will ultimately change the course of our lives and the people we are.

What is the moment a girl becomes a woman? Am I a woman yet? I thought the reason I didn't feel like a woman, even in my mid-20s, was because I had so many different role models depicting what a woman was supposed to be.

I wondered what images other women had. When they were little girls, whom did they want to emulate? As I began to think about this while on that drive home from work, I began to understand that from the answer to that question, I would be

able to define what it means to me to be a woman today.

In some of the chapters I have included excerpts from the interviews of the many women I have talked to over the years. Other chapters, I merely share my story and research I found on the subject of adulthood. In the end, each woman offers her own definition of what it is means to be a woman.

This book is not a novel or a literary work. It is written like a journal from the voices of many women. It is communicated in conversation, much like sitting down with a group of friends chatting about life.

I chose not to rewrite the work in order to be grammatically correct. This is about sharing with you the insights of many women from around the world of what it has meant to each to be a woman, and it's about my own personal entry into this sisterhood. I have also included quotes and stories from various people and some are written by unknown authors. However, if I have mistakenly not credited someone appropriately, please e-mail me at www.vanessadenha.com and I will post the corrections.

I am encouraging women all over the world, or at least those who read this book, to form "SitChats"—much like a book club—and talk about the transition into womanhood and what it has meant to each of you.

Most people silently come of age. I decided to share my experience with you. So, join me on this journey into womanhood and you will see that while looking at life through the eyes of other women, you will find your answers and discover the woman you are meant to be. I did.

When was the moment you felt like
you had become a woman?

When the Body Becomes a Butterfly

When I was 11 years old, my favorite pastime was skateboarding down "Suicide Hill." Years ago, it seemed like a steep drop but today it merely offers a nice breeze as my car picks up speed on the slight dip in the road.

It was the summer before puberty hit and the last time I spent months in torn T-shirts and muddy shoes. My biggest health dilemmas were scraped knees and an occasional stubbed toe.

I was in the sixth grade and I started to "bud," as the pediatrician told my mother. What did he mean? Was I a flower?

I was so embarrassed. I think I was one of the first girls in my class to need a bra. I wasn't ready. I hated having to strap on the "over-the-shoulder-boob-holder"; it wasn't until my late 20s that I actually adjusted to the fit.

It seems like yesterday when I flew down that hill of death, whipping around the corners at high speeds, yet it seems a lifetime ago when I think of the health problems we face today as women. Since that carefree summer, I am often reminded that my body requires attention, care and pampering.

It was particularly apparent on a trip to Chicago with my sisters.

Four of us six sisters decided to take a road trip, and while we were there, we shopped for hours. My two older sisters

20

often act more like my mother than my sisters. They sometimes complain about the way I wear my makeup or how I dress. No matter how old I get, I am still the lolly-pop-sucking, jump-rope-jumping girl in their eyes.

After an afternoon at the M·A·C counter at Marhsall Fields, where I got a makeover and bought a bag full of things my sister Sandra said would make me look sexy, we headed to the lingerie department. I apparently needed new bras. Sandra began to sift through the racks as if on a mission, while I looked for a chair to sit down. I was exhausted.

She handed me about seven undergarments and directed me to the nearest dressing room. I humored her and went to try them on. Trying on bras was the second worst thing for me to do; going to the dentist topped my list. I don't understand why the manufacturers have to make minimizers that remind me of the bras my grandmother wears.

As I snapped, buckled and pulled the bras on, one after another, there were my two sisters, Sandra and Suzanne, in my dressing room inspecting my figure. "Okay, now bend over," said Sandra. "Let me see if you are hanging out." How humiliating. As they told me to turn to the side and stand up straight, my thoughts floated to my childhood. I had an immediate flashback of the first time I ever bought a bra.

Buying my first training bra was an uncomfortable situation for me, to say the least. I really didn't want to wear one. It took my mother months to convince me that I needed to.

By the time I entered the seventh grade at Our Lady of Refuge, my "buds" became quite noticeable underneath the button-down white shirts that were part of our uniforms. They weren't the thick Oxford shirts we wore in Catholic high school. These shirts revealed a little too much of my chest. Before I started to develop, my mother always had me wear an undershirt. You know, the spaghetti-strap white shirt with a pink or purple bow in the center. But as my 11th birthday approached, I began to grow out of my little girl clothes.

By the time spring rolled around that year, my mother had enough of my bickering and complaining. She dragged me to K-mart. And to add embarrassment to the already painful experience, she had my father come along. There we were, the three of us rummaging through the training bra racks. I pretended to look. I moved hangers trying to act like I was interested while I rolled my eyes and scanned the store to see who might be watching me.

My mother was engrossed in pulling one bra after another off the rack and placing each one against my chest to imagine what they might look like on. At one point she actually wanted me to try one on over my shirt. I refused.

Due to my lack of cooperation, my mother picked out two bras, paid for them and handed me the bag. They were white with a pink ribbon tied bow in the middle to separate what should be cleavage, which at the time I did not have. She warned me that I should never walk out of the house again without a bra on. As we walked out of the store, my dad patted me on the back. It was his way of trying to make me feel comfortable. It was like he said, "Don't worry, honey, it's just a part of life. I still love you no matter how humiliating this experience was for you."

I went home that day, stuffed the bras in my drawer and went outside to play kickball with the neighborhood kids. I managed to avoid wearing the bras for weeks. I used to leave for school with my jacket on and my mother never noticed.

I felt free not wearing a bra. There was no uncomfortable itching, no pulling up and adjusting the straps, no mean adolescent boys snapping your bra from behind. If I had to wear a bra, what would be next? My older sisters were already nagging me to learn how to straighten my curly hair and wear lip-gloss. I liked to dress up, once in a while, but I still wanted to play soccer, basketball and kickball with the boys in the neighborhood. I wasn't ready to be the girl the boys wanted to kiss.

As my mind wandered throughout that moment in time, I faintly heard my sisters' voices. Then, I was jolted out of my daydream.

"Oh my gosh," Sandra shouted. "You look so great in that bra! That's the one."

Sandra grabbed one in every color and we went to counter to pay. I left the store with a new sense of confidence. I realize that no matter how old you get, sometimes in life you need your mom and older sisters to look out for you, tell you how it is and make sure you wear the right bra.

On my quest to find out the moment each girl becomes a woman, I found some answers that resembled my own experience as my caterpillar of a girl body cocooned into a butterfly.

It is a physical metamorphism before it becomes a mental one.

We emerge into women; we break from the cocoon we found comfort in as little girls much like a baby emerges from the womb. Our bodies tell us when it is time and then our minds slowly catch up.

But first we face the ugly years—puberty.

This is truly a time when the body emerges into a woman. It's as if your body is in the midst of a chemistry experiment and forming into a human body—pimples pop out, braces cover what was once an adorable smile, the Shirley Temple-like ringlets on your hair turn into what looks more like a bird's nest. Emotionally, the physical transformation becomes overwhelming and perhaps traumatizing.

I remember being so embarrassed about having breasts that I began to slouch. I didn't want to stand up straight, in order to prevent them from sticking out. It took me years to find the right fit and stand tall. This was one of my earliest recollections of being insecure about being a woman. I slowly began to realize that my slouching hindered my confidence. And confidence is what makes a woman truly beautiful.

How can you help girls realize that becoming a woman is a beautiful thing?

I was 10 years old and in the fifth grade when Sister Fidelis pulled the girls out of class and into the hallway to tell us about our menstrual cycles. I had no idea what a period really was—shocking, considering I am the fifth daughter out of seven girls in my family. You would think growing up in a household filled with women that I would have been exposed to this information long before this point. But my first real information came from a nun.

I went home that day and pretended I knew more than I did. I alluded to the fact that the school taught us "everything" about the birds and the bees, not just about our menstrual cycles, when, in fact, the lesson was more limited than I would have expected.

Sister Fidelis basically told us where the sanitary napkins were in the bathroom and that once a month we might need them in case we forgot to bring our supply to school. It was my sister Sandra who filled in the gaps.

Imagine learning sex education from a nun. Sure, she told us where babies came from, but she didn't tell us how they got there. For years I thought intercourse was a place where priests played golf.

I remember sitting in our family room, still in my plaid skirt and knee-high navy blue socks, listening to my eldest sister explain sex. I knew some stuff about sex from early-childhood exposure to information I should not have received, but Sandra didn't know that and I really wanted to know more—I wanted the truth. Once she explained it all, I couldn't believe that's what my parents did to conceive us. I was appalled. It was days before I came to grips with the information and I spent the next year and a half dreading the day I got my period.

Young girls today are exposed to much more than

generations earlier and, thanks to people like Karen Pfeffer at Crittenton Medical Center in Rochester, Michigan, there are classes for moms and daughters as the young girls transition from childhood to womanhood. This coming-of-age program focuses on the physical and emotional changes boys and girls encounter when their hormones begin to get a little wacky.

"Becoming a woman is a gift," explained Pfeffer, a maternal child coordinator at the hospital, during a phone conversation. "The class is an icebreaker for mom and daughter and it is designed to empower young girls."

Empowering women? What a concept. I certainly didn't feel empowered when my body began to change. Today, girls are taught through workshops and classes how to manage this transition.

The focus of Pfeffer's program is to teach the adolescent and foster the bonding between mom and daughter by using open communication.

When they begin the class, they both have a questionnaire to fill out—one for the daughter and the other for the mom. It helps Mom remember what it was like when she was an adolescent. It helps the girls, too. They have someone to compare notes with.

"We ask mom when she started her period and we ask the girls if they started their period," said Pfeffer. "Then we talk about their concerns when growing up and we ask moms to write about the times they felt pressured."

The moms are asked when they first learned about the facts of life or the birds and the bees: a book, Girl Scouts, a sister, a parent, here there and every where.

"Sometimes families tend not to talk, school coverage is lacking, and scouting might only touch on it," explained Pfeffer. "This is something that mom and daughter could feel comfortable talking to each other about, and moms give the answers or, at least, the correct information because we know that their peers do not have it."

It's the beginning stages of womanhood.

It wasn't long ago when talking about such things was considered shameful, yet today maxi pad commercials are commonplace. "We tell the girls that it's okay to look at your body and feel comfortable with your body," said Pfeffer. "It helps them prepare later in life. Body awareness is important, so this will increase confidence in these young women and decrease interventions later in life.

"A girl may have been wondering about that. We talk about their breasts growing, and the area where it's darker. It takes three to five years for a breast to mature. One may be bigger than the other. It makes them feel better."

The class explains the female body in detail. "We talk about how the pelvis helps a woman carry babies," said Pfeffer. "We talk about internal and external organs. We do a chart with a boy and girl and we go through the changes—acne, body hair, voice, shaving, body odor, breasts, waist and genitals. Girls sometimes think it's just them, but boys go through changes as well. It builds respect between the genders. If girls don't want boys snapping their bras, then they shouldn't make fun of their voices."

It may be one of the most difficult discussions a parent has with a child, but Pfeffer helps moms maneuver through the sex talk. "We talk about how sexuality is a gift and becoming a woman is a gift that gets unwrapped slowly," said Pfeffer. "Moms need to feel comfortable with their role as the primary educator for these girls. And daughters need to feel comfortable talking with their families."

Her Coming-Out Party

Historically, when a girl became a woman, she was introduced formally to society as a debutante. The tradition has deep roots in both the American and British cultures.

When the daughter was of marriageable age, her family

would throw a coming-of-age party proclaiming "I am woman now" in order for her to find a husband of a suitable social standing. An aristocratic family would never think of marrying their prime-aged daughter to a man from a lower social class.

I know there are groups of women who become nauseous at the thought of a woman being unveiled upon society like some sort of prize, almost stating, "Here I am world. Am I worthy of you?"

But, is there something in that tradition that can be appreciated? Can we teach young girls about sophistication, elegance, and being sexy, beautiful and very much a lady? Maybe there is a balance—a strong mind inside a sensual body. I am merely stating that in the process of being liberated, we have changed the definition of what it means to be a woman.

It seems as if trying to be sexy is being less of woman today. And I am saying we can achieve both. Beauty is in the eye of the beholder. But body image is extremely vital in molding a woman. We don't have to try and emulate the fashion models in order to be beautiful. We can only try to emulate the beauty we have within and let that shine for the outside world to see.

We can also teach young girls to take pride in their personal image. I know that I started to feel more like a woman when I began to care more about my appearance, but not in a superficial way. I started to take care of my body. I began to walk. I educated myself on healthy nutrition. I began to enjoy tinting my hair, wearing makeup and occasionally buying the latest fads.

While history has its debutantes, we have the single scene of the 21st century. In some communities there are still debutante parties but for the most part, an 18-year-old female in the U.S. has replaced the corset under the dress for perhaps just the corset. Instead of parading herself around a big ball put on for her honor, she heads to the local bar looking to find an eligible man.

Who actually "comes out" formally and states she is

officially part of this exclusive group of women? My niece came close. Ashley called her six aunts the day she got her period to tell each of us that she was, in fact, a woman and that she expected to be included in on the conversations we often excluded her from.

Not quite the debutante arrival portrayed in a novel, but an announcement well taken. "I am a woman, now," she stated boldly. I chuckled a bit, but part of me was envious of her ability to define herself with such confidence at 12 years old.

Create Your Own Coming-Out Party by Creating a "SitChat" Party

Why not empower young women embracing this moment? Your physical transition into womanhood doesn't have to be awkward or traumatic. Adult women can encourage young girls to stay on a healthy path. Here's how:

- Puberty is a great time to start a journal. Keep track of the changes.
- Have a slumber party with other girls and talk about the changes.
 This could be the start of a young girls "SitChat" (see chapter on how to create a SitChat)
- A group of moms and daughters, sisters, nieces, cousins and friends could gather for an informal "SitChat" and the topic could focus on menstrual cycles and the first real sex talk.
- Adult women can sit down with young girls and talk about the first time they got their periods.

This transition marked womanhood for many other women

I Knew I Was a Woman When... *I showed up to go to school in a dress. My mother almost fainted.*
I never really understood what the term "woman" really meant. I was a tomboy from day one. I was always in trouble, always fighting with the boys in the streets, always perturbing the teachers, always doing something to the point that, when I was 9 years old, it was just a rule of thumb that I got a spanking every single day. I would come home with my clothes torn and muddy and that whole thing.

Finally, it just dawned on me that this wasn't working out, that something was wrong here and that I was getting the short end of the stick. Of course, the big fight with my mother was "Wear a dress, comb your hair." My mother's favorite question was, "When are you going to become a lady?" You know, "a lady."

My grandmother, who lived next door to us, always cooked meat and it was always well done. Who knew what rare was because they didn't cook rare meat back then. I must have tasted it somewhere because I would never eat meat unless she made it rare for me. And, that was the other thing always said to me. My grandmother would say, "You continue to eat this red meat, you are going to grow up to be a man." I heard this all the time.

I was an only child so I didn't have siblings to compare to. I had a lot of cousins, but the only "person" I had to talk to was my dog, a Dalmatian named Spot. We had a staircase with a landing and that was my little haven. I would go into the corner of the landing between the stairs and talk to my dog. I remember this very well. I said to him, "This is not working out. I've got to change something here. My mother wants me to be a lady. My grandmother thinks I am not doing something right."

It literally happened the next morning. I showed up to go to school in a dress. My mother almost fainted. I remember my aunt sitting there. She lived next door. They were having

*coffee. I was very mannerly. I said, "Good morning, Mother."
I thought she was going to have a heart attack. My mother
said, "How wonderful you look." And my aunt said, "That's
the first time I've ever seen her in a dress." Something
internally said to me, "If I don't feel this way, I have to act this
way." That was really what I thought and I was just 9. From
that point on, the tables turned. I didn't get a spanking
anymore. I suddenly started to notice the opposite sex was
looking at me in a different way and I thought, "There is
something to this thing. There is something to being a woman
or a lady, as my mother put it."*

*So, that is when it started. And then you have the whole big
thing with menstruation. I started young. I was about 11 and a
half. That was a big deal and that is what my mother said was
being a woman. You started to menstruate.*

*The next thing I found, as far as feelings go, was my first
kiss. I was 12 years old. It was outside my house, up against
the buckeye tree. He was the football star. He lived down the
street, was four years older than me, gorgeous and ended up
being the head of his class at West Point. I remember coming
home. I started writing in my diary about that feeling. And that
feeling is something I never felt before. And that's when
probably I started to feel what being a woman is all about. I
kind of liked this. —**Shirley Jones***

~

***I Knew I Was a Woman When…** I opened a Christmas gift in
front of the entire family and what fell out of the box was a bra.*

*I was in the eighth grade when my mother bought me my
first bra. One day, while my mother and I were Christmas
shopping, she asked me if I thought I needed to start wearing
a bra.*

*I told her I definitely needed to wear a bra and pointed to
the two minuscule bumps on my chest, which actually looked*

like mosquito bites. Up until this point, I had been wearing undershirts. My mom let me pick out the bra. It was white, nothing fancy, just some polyester material held together with elastic. But to me, it was the greatest undergarment in the world. It meant I had graduated from girl to woman.

On Christmas morning, the whole family gathered by the Christmas tree. It was the family custom to take turns opening presents. When it was my turn to open a present, I chose a nicely wrapped square box to open first. I ripped open the box and pulled out a beautiful hot pink and black dress. I stood up and held the dress against my body to see how it looked, and out fell the new bra onto the floor. The looks on my father's and brothers' faces were ones of bewilderment and amusement. I couldn't believe my mother had wrapped my first bra as a Christmas present.

I gasped and grabbed the bra and hid it under my new dress. It was too late. My whole family began making comments on how I wasn't a little girl anymore. Little Joanie was becoming a woman and the whole family had witnessed it.
—Joan Abbo Collins

~

I Knew I Was a Woman When... *I was about 5 years old.*

I loved to play dress up in my mother's heels and by wearing her clip-on earrings. I knew then that I was on my way to being a woman. **—Rachel Nevada**

~

I Knew I Was a Woman When... *my menstrual cycle began.*

It was exactly 20 years ago during my 13th birthday party that I got my first period. It was on that day that my mother said, "Welcome to womanhood." I was in pain and was not thrilled. I told her, "You can have it back." **—Faith Green**

31

~

I Knew I Was a Woman When… *my mother gave me a hijab.*
It was the first day of third grade, in September of 1980,
when my mother presented me with my hijab. The hijab is a
traditional headscarf worn by Muslim women who seek
personal modesty in public. My mother had me appear before
my classmates with my head covered.

Even in southern Iraq, where I grew up, this was a strange
sight. I lived in the largely secular city of Basra, and no one in
my school of 700 wore a hijab. The Iran-Iraq War had just
begun, and many Iraqis saw the hijab as a symbol of Iran's
Islamic regime: our sworn enemy. In class, everyone stared at
me, and some even teased me by yanking the scarf off my head.

My teacher, a Christian, could not understand my decision.
She turned to me in class and asked me to explain the cloth on
my head. This, I answered, is part of my religion. My family's
religious tradition asks that women cover their hair. The hijab,
I told her, is who I am.

Today, the hijab remains an important part of my identity.
Everything beneath it becomes private, even precious. I feel a
deep obligation to cover my hair, and make an open-minded
choice to place a thin divider between my body and the outside
world.

Of course, since September 11, the scarf I wear is a charged
symbol, a new kind of barrier I must struggle to overcome.
Though some women fear wearing a hijab in America, my
experience has been just the opposite—people are respectful
and understanding. I showed up at work and discovered many
female colleagues—all non-Muslims—wearing hijab as a sign
of sisterly solidarity.

I don't want to force my beliefs on others, and I respect
Muslim women who choose not to wear hijab. As mothers, we
must educate our children not to judge people by the clothes
they wear or their religious identity, but by how they behave.
*—**Zainab Al-Suwaij***

When Someone Calls You Mommy

The closest I've come so far to being a mother is babysitting my nieces and nephews over the years.

I never had this soul-wrenching desire to have children, unlike my sister Stephanie who, since childhood, wanted to be a mother. I had dolls but I liked playing board games more than I liked to play house. In fact, I never really knew what I was supposed to do with a dollhouse or a Barbie, for that matter.

However, there were two dolls that interested me for while as a child. The first doll was able to crawl. My Aunt Natalie bought her for me the Christmas she visited my family in California. I imagined her being a real baby as I watched her little bottom with white ruffle underpants move around our family room, until I came home from school one afternoon and noticed that my 3-year-old sister, Veronica, broke her legs off at the knees. I didn't know what to do with her after that. I knew the doll ended up in the dumpster somewhere, even though no one ever told me that. It was now considered junk. I still don't like to think about it.

The second doll that I spent hours playing with stood about three feet tall. She was my Christmas gift the following year from my parents and she was more of an imaginary friend I could see, rather than a doll I played with. I propped her up across the table from me and we played cards or jacks. I always won. My sister Sally threw her away when we moved from

California to Michigan. She was old and raggedy by that time and Sally thought she was trash. Months later, I found myself lying in bed at night missing her.

There is something about taking care of something or someone else that defines us as adults.

In the movie *For Keeps* Molly Ringwald plays a high school senior who gets pregnant by her boyfriend. She is also an aspiring writer. When the baby is first born, she ignores it. One afternoon when the cries are intolerable, she holds the baby for a while and sits down to type and she writes about feeling like her childhood had been ripped from her as she pushed the baby out.

Maybe that is womanhood. The moment you know your childhood is gone. The feeling of true freedom is a faint memory tucked away in your treasure chest, lying next to your first Barbie doll and roller skates. You no longer know what it is like not to have a bill to pay, a time clock to punch, a report to write or a child who depends on you.

As I grow older, I find myself wanting a child. I don't know if I will ever have one. I hope so. But, I do understand how profound the moment a child comes into your life can be. I have to admit that every time I see a baby inside a stroller or being cuddled by her daddy, there is a part of me that cries inside. I think of the love I was given from my father and I hope I can pass that on to my children.

I have the utmost respect for women who take the responsibility of this great honor to the highest level and who truly love this role. Birth is a miracle and parenting is a privilege; I can appreciate how giving birth was the moment that typified womanhood for so many women.

This is not unique to the human race. I was struck by this relationship of mom and daughter while watching *Jane Goodall's Wild Chimpanzees* at the Detroit Science Center's IMAX Theater. The renowned primatologist was in town lecturing to the audience that day. And, like thousands of

people who have come to know her work and who have met her, I was in awe.

Prior to my news director giving me the assignment to interview her, I knew little more than the basics about Dr. Goodall. I was amazed by the fan club that waited outside the press conference room for her autograph, and I felt privileged to be inside the room.

After viewing the film and interviewing the subject, I thought, "What a woman." I knew she needed to be included in my book. In just 20 minutes, her work changed my view on life. Sharing just a snippet of it here, I hope it will do the same for you.

In the documentary, Goodall talks about how chimps learn. Grooming is one of the most important social behaviors in chimpanzee communities. It helps them maintain—or even improve—friendships. But how do they learn this?

Answer: by observing their mothers. There is a time perhaps in every creature's life when she embarks on adulthood and each child observes things from her mother. In a chimp's life, it is the mother who influences the child. The females procreate with various males, and before DNA testing it was unknown who the fathers of the chimp babies were, but they all knew who their mothers were.

Goodall credits her own mother for the encouragement to choose the path she has journeyed, having spent more than 40 years in Africa studying chimpanzees. Her mother, Vanne, had these words of advice for her daughter: "Jane, if you really want something, and if you work hard, take advantage of the opportunities, and never give up, you will somehow find a way." Jane did.

Goodall had few roles models, having been born in England in 1934. She contemplated secretarial school while working with a documentary film company. At the age of 23, a friend invited her to Kenya and Jane jumped on board.

Shortly after arriving in Africa, she was offered an assistant

job by paleontologist and anthropologist Louis Leakey. She went on a fossil hunting mission and the trip inspired Jane to pursue a career in science, even though her real desire was to study animals in the wild. On the shores of Lake Tanganyika, Jane and her teacher talked about studying chimpanzees.

British officials resisted the idea of a young British woman venturing alone into the wilds of Africa, so when Jane's mother offered to accompany her daughter on the trip, the officials agreed. Jane and her mother arrived at Gombe Stream National Park in July 1960 and Jane went to work.

Her achievements are revered and her work studied by thousands of students across the world. She is most noted for being the first person to witness chimpanzees creating hunting tools out of sticks. Her work revolutionized the field of wildlife biology and challenged humans to reconsider their role as "Man the Toolmaker."

I realize that the world will have a limited amount of Jane Goodalls—women who dedicate decades in a foreign country to study living creatures while making an impact on science and history. But I am certain that anyone of us can become a Sandra Jolagh.

If I had to define motherhood, I would do it in one word: Sandra. She is my eldest sister and the mother of four intelligent, passionate, creative and well-mannered children. I am more than just a touch biased due to the fact her third child, Renna, is my goddaughter, and the sweetest girl I ever met.

Motherhood is a sacrifice. Sandra reminds me of my dad, who was often referred to as the family taxi driver. If you needed a ride, Dad was always there. Sandra totes her kids to three different private schools, softball, hockey, ice-skating, gymnastics, work, the library and to friends' houses. Her life is defined by her children. She once confided in me that she envied women with careers, being a woman who put hers on hold to raise a family.

What she didn't know is that I envied her. She met a man,

fell in love and had a family. I fear that I am almost too selfish to give it all up to have children. Sometimes I don't believe I have the strength or endurance to cope with flues, scraped knees, playground cruelty, homework, puberty and teenage years. I went through it and to see my own children struggle, suffer, change and mature without being able to control every moment, to take away the pain and to guarantee that every day will be blissful, is almost too much stress to cope with.

I don't know what exactly defined womanhood for Sandra, but I do know what defines motherhood for me—her.

~

How motherhood marks womanhood for so many women

I Knew I Was a Woman When... *I became a mother.*

The day my daughter was born was the most significant day in my life and was the day that my womanhood was realized. For me, becoming a mother was a highly personal and intimate experience that continues to this day. For that reason, it can't be explained. —**Candice Miller**

~

I Knew I Was a Woman When... *I got pregnant with my son.*

The moment I felt most like a woman was the moment I was pregnant with my son, Deryk. It was truly the most exciting moment of my life. I was in maternity clothes minutes later! I was so thrilled and grateful because I had come way too close to missing out on this life-changing moment, having bought into the feminist propaganda as a Sixties college student and getting my tubes tied, lest family interfere with my career goals! A PBS Nova program on the miracle of conception, pregnancy and birth totally turned me around. And I thank God

37

for that every day of my life. —**Dr. Laura Schlessinger**

~

I Knew I Was a Woman When… *I gave birth to my daughter. Holding her in my arms and beholding the human being I labored to bring into the world gave me an appreciation for being a woman that was very unexpected and all, encompassing. The exclusive bond that we encountered and the feeling of being responsible for her growth and development gave me a unique perspective on the role of women in the world. We were all alone in the room, and as I held her and experienced the purest form of unconditional love, for the first time in my life, I realized that I had an exclusive relationship with her and commitment to love her and pass on the wisdom of a lifetime to her.*

It was an awesome moment. Similar to what Abraham Maslow, psychologist would refer to as a peak moment in my life. This was very unexpected because I had rebelled against a woman being defined by motherhood and domestic responsibilities for most of my life. I was a tomboy growing up and identified with my father, not my mother, who was primarily responsible for raising me and my six brothers and sisters. Somehow, much to my surprise, the experience of birthing changed my point of view about the meaning and experience of being a woman. —**Laurie Mastrogianis**

~

I Knew I Was a Woman When… *I had my first child. I was very young. I was 17 years old. It was a miracle just to be pregnant, to give life. And then that gorgeous little girl came out and she had all the toes and the fingers, two good ears and two wonderful eyes. I looked at her and the accomplishment and I thought, "It is so great to be a woman."*

I felt just so womanly and went on to have the other four kids to feel that way. —**Florine Mark**

~

I Knew I Was a Woman When... *I felt confident as a mother and wife.*

Originally, I thought that when I married my husband I had become a woman. I realized I had not, so I thought it 'would happen' after I had a baby. To my surprise, it was much later. When my daughter was born I was 26 years old. Not until I turned 28 did I feel more confident with being a mother and a wife.

I knew that I had to maintain order in my life for my daughter and for us as a family. My beliefs and values had to be consistent with how I lived daily. —**Lisa Patrico**

~

I Knew I was a Woman When... *I gave birth to my first child after 30 hours of labor.*

The moment I felt like I had become a woman was when I gave birth to my first child at age 24, on October 17, 1984, after 30 hours of labor.

That was a defining moment for me. I thought it was absolutely incredible to be able to bring forth another completely whole, healthy human being from my body. That was a miracle to me—a God-given miracle. An extension of that miracle was to nourish this beautiful baby boy from my breasts, which first produced milk and then the healthiest form of sustenance that God could create, mother's milk.

Armed with the knowledge that a lot of women were physically able to breastfeed, but just chose not to, made me feel even womanlier and even more maternal. And being able to give birth—to bring forth life—is one of the reasons that I

am glad that God made me a female and subsequently, a woman. *When a lot of women are barren and can never feel quite "whole" because they're not able to give birth, I feel that I have been blessed.* —**Vanessa C. Hines**

~

I Knew I Was a Woman When... *I first put another's needs ahead of my own.*

I was 26, and four and a half months pregnant with my first son, now 21. This was an at-risk pregnancy, and for seven weeks I'd lain in bed, frightened, forbidden to move, all the while bleeding and threatening to miscarry. The prospect of 22 more weeks in bed overwhelmed me. I'd been an active woman—how could I possibly lie flat and let others care for me, my husband, my job and my home? And why was this even happening to me? I'd wanted a baby so badly, had even gone through years of fertility tests and treatments just to get this far. And now this. Why me?

Then I felt it—a feeble scratching deep within my belly. The sensation of butterflies in my stomach, but lower. I knew that this was my child, still safe in this incubator I'd become. Finally I realized that this whole experience was not about me. This was about someone else, someone I didn't even know yet, but loved already. I was a woman. I was a mother. —**Theresa Falzone**

~

More "SitChat" Questions...

- How did your mother influence you as a woman?
- Ask your mother how she defines being a woman today.
- What qualities about yourself would you want your daughter to most admire or respect?
- What kind of mother do you want to be?

When They Heard Me Roar!

During my freshman year in high school, my psychology class was assigned to write an essay on a person we most admired—someone who was self-assured. While my classmates wrote about Madonna and Princess Diana, I wrote about my sister Sally. I presented a speech about her as well; she was one of my earliest roles models. She emulated confidence, drive, kindness and strength. I wanted to be like that.

Sally often took me to church with her. She is nine years my senior and we would work together at our father's store on Sundays. I was dragged along mainly to give my mother reprieve. If left home, I would most likely end up fighting with my sister Veronica.

We always ended up at church late, when the parking lot was packed, so we parked in the back and had to walk several feet to the church. Sally took long strides, with her purse in one hand and her keys in the other. Sometimes she would hold my hand just to make sure I kept up with her.

Her clothes were always pressed and matched. I knew where we were headed—into mass—but Sally walked as if on a mission. I often looked at her and wondered what it was that she knew and I didn't. How did a girl who grew up in the same household born to the same parents end up so self-assured, when I had no idea where life would lead? I feared the future while she seemed to hold it in the palm of her hand, completely

in control of it.

Sally, like all of my sisters, and my mother, deeply influenced my life. She always told me, whenever I faced difficulties, that things would fall into place as they should. And she is right—they always do.

I wanted to mimic her confidence, her drive, and her ability to give so much of herself without ever asking for anything in return. As the years passed, I continued to look to Sally for guidance and advice, although sometimes I didn't ask. I merely observed her behavior and made my decisions based on what she did.

I began to stand up and make others take notice of me. My insecurities about my weight, petite stature and fear of life, began to transcend into challenges. They became my weight problem, my figure, my fears. I owned them and they didn't control me. It wasn't about what my classmates thought about me, it was what I thought about myself and how I would change the things I didn't like. At some point, I stood on the highest mountain and made the world take notice of my strengths, talents and goodness while I worked on the rest. In a subliminal way I shouted, "I am woman, hear me roar!" The role models I had enabled me to do this. I saw goodness in someone else, which helped me see goodness in myself.

The influences young girls have today are obviously much different than what I was exposed to and even more so from what my mother was exposed to as a young girl.

Girls today also have many more resources to guide them into womanhood. As a journalist and professional speaker, I met Kimber Bishop-Yanke, founder of Girls Empowered, an organization that offers programs to girls of all ages. The programs focus on self-respect, self-confidence, personal empowerment and positive body image, as well as ways to achieve optimal health. She teaches what I desired my entire life, how to have your own voice. I sat down with her one afternoon and we talked about empowering young girls today.

Vanessa: How do you empower girls as they become women?

Kimber: Our goal through our activities is to get girls to have their own thoughts and dreams and believe that they have their own voice and opinions. So, our workshops building self-confidence and educating them on nutrition, etiquette and self-defense are designed to get a girl to make her own choices about who she wants to be what she likes, what she doesn't like, what she stands for, what kind of relationship she wants to have, what kind of career or business she wants to have, and so on.

Vanessa: What images do young girls have of what a woman is or should be?

Kimber: Today, girls have very confusing images. Most images are sexy, show a lot of makeup, glitz, glamour, and are about being famous and doing things to yourself so you look a different way. It's not natural beauty, but contrived beauty. A lot of girls see women in powerful positions and they don't realize what they had to go through to get there. I do believe they think they can be the next president of the United States or the president of a company or a sports player, but they are also given very confusing messages of what it is to be a female.

Vanessa: When I think of giving girls mixed messages I think of Monica Lewinsky. She has been put on some kind of pedestal. The media seemed to tear her apart at the same time they elevated her into something young girls are supposed to admire. I can accept people making mistakes, but by elevating her, we are telling young girls, "All you have to do is have sex with the President, and you'll become rich and

famous." What messages are we sending them?

Kimber: It's not just the Monica Lewinskys of the world. There is a continual portrayal of the ideal woman as the thin, made-up model, the *Friends* stars and Britney Spears. The biggest problem today is that instead of marketing to high schools like they did when we were growing up, they are marketing to 5-year-olds.

Cosmetic companies are doing this through advertisements. Before, they didn't purposely advertise to that age group and today they are. The clothes that are for first-graders you would expect a teenager to wear: the glittery jeans, the hip huggers, the lace clothes.

Vanessa: Where are the parents in this?

Kimber: There is a huge problem with moms dressing like their daughters. There is little distinction between who the mom is and who the child is. Parents want to be their children's friends, so girls don't have clear boundaries or limits. Young woman they are getting on the Internet and pretending to be young adults, so while they are dressing and acting like young adults, they are emotionally not mature enough to handle these things.

Vanessa: How do Girls Empowered take negative influences and replace them with positive ones for young girls?

Kimber: We teach them to be critical thinkers when it comes to the media, so that when they look at advertisements and TV shows they can recognize when they are being marketed to and they can make a conscious choice. Being happy, confident and successful is not about having all that stuff. It's not

the products that will make her the woman she wants to be. You have to have it on the inside. You can't buy it, you can't look it. We have to give girls the tools to work on the inside and really think about who they want to become instead of being this passive person going through life letting other people to define them. We have to ask: "Who is giving you these messages? Who is getting you to try to be someone else?" Their friends are trying to get them to be one way. Their parents are trying to get them to be another way. School, society, the media—they have to really look at all those things and decide: "This is who I want to be."

Vanessa: Do you help girls identify positive role models?

Kimber: We talk about actors and celebrities, and what makes a person a role model. Just because she is beautiful or famous doesn't make her a role model. You can admire her for those things but you want to find what she is about. I use my role model, Sarah McLachlan, who wanted to do an all-female band tour. Her producers told her no one would ever commit to that, so she started her own. That's why she is my own role model. Princess Diana is someone who is very famous but what was Princess Di all about? She was about working with kids who had AIDS, and with landmines. That behavior would make her a role model, not because she happens to be Princess Di. We talk about the behavior of a person, her actions.

Vanessa: How do you help young girls identify role models at home?

Kimber: We talk about all the different things a

woman can be and try to learn about as many different possibilities. Sometimes your parents want you to be a teacher but that is not your passion. We find ways to discover and learn about other people and ways they have done things. I tell them to travel so they can meet people and open their world. Don't say, "This person doesn't act like me or dress like me, so I don't want to be her friend." You usually learn the most from people who don't look and act like you. You would be surprised at the wealth of experience you have. People tend to gravitate toward groups that are just like them instead of trying to expand that.

Vanessa: How can mothers be positive role models?

Kimber: I talk to them the same way I talk to young girls. If the mothers feel like they have low self-esteem, you need to have an action plan to help them get it. You want to own your business but you don't think you can. Make goals and work on small steps. If you're shy in front of people, do things that make you have to get in front of people. It is the same for the girls.

If moms want to be good role models, they have to walk the talk.

Vanessa: When you were growing up, what were some of your influences?

Kimber: I always thought of the negative ones. I was the first female class president at my high school in Lexington, Kentucky. I was a rebel. I went against the norm. I always saw things I didn't like. My mother was a homemaker later became a teacher.

My dad provided a very sheltered, protective life

for his three girls. His whole goal was for us to grow up and marry someone with the lifestyle we were accustomed to.

At a very young age, I had a mole on my nose and a scar on my knee from a bike wreck. My parents wanted me to get cosmetic surgery on both of those things because they said the boys would like me more, mainly my dad. I said if the boys don't like me for who I am, that is their tough luck. I was only 10 years old at the time and I have no idea where I got the ability to say that, but I always felt that I was a valuable person and that I have a lot to offer. That is what I try to teach girls.

Vanessa: I can relate to what you talk about. The reason I wrote this book is because I was trying to find myself. I felt like I had a voice, something to say and I just didn't know if anyone was listening. I never felt like I was making any decisions in my life.

Every few months someone sends me statistics about women via e-mail, and I have received the information below several times. I thought it was only appropriate to share it with you. I often arm myself with the following facts when I talk to women about body image and self-esteem.

- There are three billion women who don't look like supermodels and only eight who do.

- Marilyn Monroe wore a size 14.

- If Barbie was a real woman, she'd have to walk on all fours due to her proportions.

- The average woman weighs 144 pounds and wears sizes between 12 and 14.

- One out of every four college-age women has an eating disorder.

- The models in the magazines are airbrushed—not perfect.

- A psychological study in 1995 found that three minutes spent looking at a fashion magazine caused 70% of women to feel depressed, guilty and shameful.

- Models 20 years ago weighed 8 percent less than the average woman, today they weigh 23 percent less than the average woman.

An English Professor once wrote the words, "Woman without her man is nothing," on the blackboard and directed students to punctuate it correctly. The men wrote: "Woman, without her man, is nothing."
The women wrote: "Woman! Without her, man is nothing."

—**Author Unknown**

I Like This But I Hate That

I Knew I Was a Woman When... I realized I liked yoga.

I believe that truly being a woman means knowing what you like and what you don't like—who you are as a person. I've always wanted to do yoga, but was too self-conscious to try it. That changed when my sister Veronica bought a couple of tapes after my father passed away to help my mother relax.

My mother used to do yoga when we were growing up and the meditation poses seemed so mystical. I envisioned myself being transferred to another place with every breath. I wanted to be whisked away by this exercise but never had the confidence to join a class.

I know. Who would think it would take nerve to try yoga? Let me explain. I'm an athletic woman masked behind an overweight body. I like playing sports and sometimes watching them. However, I've always been fearful of being athletic because my physical appearance would not define me as active.

Somehow, the things that I loved to do as a child became this obligation. I walked miles in my neighborhood because I had to lose weight. I did aerobics, rode my bike, swam and lifted weights because I was fat and not because any of it was fun. Yoga just got lumped into the many things I *should* be doing instead of what I *wanted* to be doing.

I switched my thinking.

I began looking at exercise as a gift to myself. I am a person who does yoga because it calms me after a stressful day of following a story and meeting my hourly deadlines. I eat salads with lots of colorful vegetables because I like the taste of them and I feel better when I am active and eating healthy foods.

I began to spend time living life instead of going through the motions like a load of clothes spinning around in a washer and then being tumbled dry. I think 20 years went by and life just happened. One day, I woke as a reporter at a network-owned radio station, more than 50 pounds overweight, single and still living with my parents, and I wondered how I got here.

I realized that when I started to pay attention to what I was seeing, hearing, feeling and experiencing, I felt more like an adult. I began to live life. I took tennis classes and enrolled in a softball league. I joined a book club.

I began to re-evaluate my career and I took a more of an active role in my single life just by going out more with friends. I took a makeover class from a well-known makeup artist in Michigan. I started to glance at fashion magazines just to get a better sense of my own style—what I like and look good in.

I knew I had become a woman when I began to live life knowing who I am and not justifying my beliefs or my behaviors.

When I began to try to figure out why I hadn't felt like a woman, I looked to all the women in my life who have influenced me and whom I have tried to emulate. I realized that our journey into womanhood is largely directed by the people we have shared our lives with while growing up.

When we were little girls, we had images in our minds of what a woman was or should be, so perhaps it wasn't until we felt like those people that we became women ourselves.

If your mother defined womanhood for you, but you never really became much like her, do you never feel like a woman? Along with figuring out my own tastes and interests, part of

becoming a woman was accepting reality—I am not a size 12. I squeezed, tucked and pulled myself into pants, shirts and skirts two sizes too small on many occasions. As long as the pants didn't rip and the buttons on the top didn't pop, the size fit.

My sister Veronica came home with a bag filled with clothes from August Max and another from Lane Bryant. There was no way I was going to look inside, let alone try on anything she bought. I am NOT a full-figured woman. I just imagined these ruffled shirts that covered your neck and tea-length floral dresses that schoolteachers in the '80s wore. Veronica began to pull items out of the bag and modeled them over her clothes.

I was surprised how fashionable they looked. On that day, I accepted the fact that I wear plus sizes, and I became more of a woman. On a good day I fit into a 14, but often I look better in a 16.

There was something psychologically negative about wearing a plus size. It was a group I didn't want to be in, but whether I liked it or not, I was a member of the "Big Girl Club." I just remind myself that Marilyn Monroe wore a size 14, so I've heard. More importantly, I think about how confident I become when I feel good about myself.

Realizing I liked yoga also helped me learn to accept myself. I am a real woman with curves who likes yoga.

Who are you?

If you are my niece Ashley, you are a teenager who wants plastic surgery. One Sunday afternoon, my niece Ashley was looking through a stack of fashion magazines I have stashed away in the corner of my family room. I kept them hoping to find something witty and appropriate to include in this book, perhaps a quote from a famous person or some fascinating fact about a household name.

I never really sifted through them. Glancing through fashion magazines just reminds me of the woman I am not. I've

recently come to terms with that fact that I am not a size 2 like my sister Stephanie. This day Ashley was turning page after page. Some of the issues dated back three years. "I can't find anything I like," she said.

"What are you looking for?" my sister Veronica asked.

"I'm trying to find a nose I like," she replied.

At first I laughed. I've known for a long time that Ashley is not satisfied with her powerful Middle Eastern nose that slopes slightly down.

I just found it humorous that she sifts through glamour shots looking for the perfect face and I avoid those same publications knowing I never can.

Realizing I liked yoga moved me a step further toward accepting myself for who I am—the 5'1" brunette female with hazel eyes and a body resembling that of an adult-size Cabbage Patch doll.

Work with what you got. That's the phrase I've heard for years.

And that's what I'm doing. I am creating my own identity through the clothes I buy, the makeup I wear and don't wear, the style of my hair, the classes I take and the magazines I read and those I don't.

I knew I was a woman when I started to become the woman I wanted to be.

If it's plastic surgery that will make someone more confident, I won't be one to judge, but I fear that the need to be someone else overpowers the ability to accept oneself—and when does it become enough?

Parents are giving daughters breast implants as a birthday gifts. What are we telling our young girls? The media already puts a great emphasis on physical appearance. Why should those who are supposed to guide us condone altering our appearance just to be accepted by what is perceived to be the norm?

Being a woman is figuring out who you are and accepting

it. You must live by your standards and not by society's, or some guy or your gal pals from school.

In the movie *Runaway Bride*, Julia Roberts struggles with commitment. The character played by Richard Gere made Roberts' character realize that she became the woman each man she dated wanted her to be. When asked what kind of eggs she liked, her answer changed depending on what man she was with at the time.

Toward the end of the movie, she sat in her apartment taste testing various kinds of eggs—poached, scrambled, omelets and egg whites—until she figured out what kind of eggs she preferred.

Perhaps that is the question we should all ask ourselves as a test of knowing who we are and what we like. What kind of eggs do you prefer? I have had the same favorite kind of eggs since I was a child. My grandmother used to make them and we called them Yuma's eggs. "Yuma" is "grandma" in Aramaic, and for years I thought my grandmother created the recipe until I grew up and realized they were called omelets. She made plain omelets and we poured syrup on top—delicious. Today they are still my favorite kind of eggs.

~

I Knew I Was a Woman when... *I found myself.*

I don't look at it as "becoming a woman." I felt like I was asleep until I was 30. I went to Nepal and that totally changed my life. I was on this continuous search of what I wanted. I knew what I didn't want, but I didn't know what I truly wanted. I was going with whatever came to me—college, my job, graduate school. I never made conscious decisions because I didn't know what I wanted to do.

My first real conscious decision was when I was working at a toy company. I had an opportunity to spend a month in Nepal and I decided that I wanted to have my own company and

influence young girls, even though it meant I could hurt my own career.

When I went to Nepal I thought, "Why am I working for a company that does nothing but make top management filthy rich?" I went back home thinking I wanted to do something that would make a difference. I wanted to create a company and that was going to be my dream. When I got back from Nepal, it was a domino effect. I like to say my life kicked me out of life. Within a year, I was in San Francisco starting my own business. And within two years I started my company, "Girls Empowered." —Kimber Bishop-Yanke

Life Isn't Fair,
But I'm No Longer Crying About It

You remember the phrase you uttered as a child about a thousand times: "That's not fair." I can recall several occasions where the same words passed through my lips. What did the adult in the room usually reply back? You know: "Life isn't fair."

Well it isn't.

How many incidences in our lives can we recall that prove that statement to be true? It's the same argument I have used with atheists who give many examples of why a God doesn't exist, like natural disasters, the death of a child or a person suffering. It is often asked, "If there were a God, why would this horrible thing happen to this person?" I usually have many ways to reply, and among them I say, "Life isn't fair."

I am not going to get into a debate on theology or begin a lecture on the existence of God. I am talking about human beings learning to accept the fact that life isn't fair. I include faith in this acceptance because I have learned to live by one simple philosophy. And when you believe in this philosophy you must accept that life isn't fair. The philosophy is the Serenity Prayer, which reads:

"God grant me the serenity to accept the things I cannot change, the courage to change the things I can and the wisdom to know the difference."

I know it is no longer politically correct to talk about God in public, let alone to write about Him, but honestly I don't care. I have learned that life isn't fair, politically correct or not. It just isn't...and that's it. Some things are the way they are because they are; no explanation is offered and it doesn't have to be fair.

It's the time a coworker got a promotion even though you were obviously more qualified. It's the time you didn't make the cut for the baseball team even though you were clearly a better player than the person who did. It's the time you lost your job because of a mistake someone else made. It's the time someone stole your idea and passed it off as her own. It's the time someone who pretended to be a friend and confidant went behind your back, undermined you and took a position you jockeyed to get for months.

Those scenarios are all unfair. But they are what they are. And most of the time there isn't much you can do about it. I know because I have been in many of those situations.

But in this ability to accept that life isn't fair and that some things are out of my control, I have also learned many other valuable lessons. For example, sometimes things happen for a reason even if, at the time, it appears to be unfair. I also strongly believe that what you put out in the world comes back to you. You can call it karma or "what goes around comes around"; it doesn't matter how you define it.

Life is filled with challenges and obstacles and we do our best to overcome, to fight, to survive and to win. Sometimes things don't happen as we planned them. I had an idea of what path I would take. In some ways I am exactly where I thought I would be at my age, yet I am so far behind everyone else.

Sometimes in life, you accomplish what you set out to do and you get to the place you had envisioned would bring you ultimate happiness. But when you get there you find yourself wondering: "If only I did this... If only I had this... If only I could get this job... If only I could lose weight... If only I

could get married… If only I was making this much money."
But then you get those things and it's not at all what you
expected. You are still unhappy, unsatisfied and unsettled.
Part of becoming a woman is accepting life for what it
is—the good and the bad. We look for all those big moments
to find happiness instead of finding happiness every day in the
little things that happen. I guess it takes a belief in a higher
being to live like this because you have to put faith in someone
or something to stay sane in life and to accept the fact that life
isn't fair.

How else do you justify a tornado ripping through and
destroying a small town? Or a baby suffering with cancer and
eventually dying, or 10 students killed during a shooting at
their school, or your elderly parent being the victim of road
rage. How do you accept and live with the unfairness?

My father battled cancer for a while and every day I would
say, "It's just not fair." A little girl, very close to my heart,
spent nearly a week in the hospital after having a seizure. The
9-year-old didn't understand why she ended up in the hospital
and why her friends got to play outside while she was stuck to
tubes and confined to a hospital bed. "It isn't fair," she said to
her mother.

It's a concept we all learn at some point in our lives. Once
you accept it, you can agree not to cry about it anymore. It
doesn't consume you. I know life isn't fair and what has freed
me from the anguish of that reality is no longer comparing
myself to other people on a daily basis. I did this since
childhood. Girls in my class always seemed smarter, funnier,
prettier, more popular and just plain happier. On many
occasions, I would come home from school crying to my father
because some girl had better looking hair, or thinner legs,
played baseball better or made the cheerleading squad and I
didn't.

As I grew older, I would compare myself to other
journalists, mainly Oprah Winfrey. I remember turning 30 and

thinking: Oprah had her own syndicated talk show at my age and I was still working at the same radio station making a pathetic amount of money in comparison to her.

Every time I did this my dad would say the same thing he had been saying for years: "Don't compare yourself to people who seem to have more than you because in life there will always be someone prettier, richer, funnier and happier. Compare yourself to those who have less, and it is then that you will appreciate life."

I didn't quite get it until he died. His body lay in a casket and I sat looking at him and I realized that it didn't really matter who appeared to have a better life than I did. What mattered was how I live mine. My dad lived a simple life but died a good man. I set out to elevate myself to the human being he was on Earth. I am not comparing myself, but merely striving for a goal. I will never have a model figure, or have my own syndicated talk show by 30. The time has passed, but I can always be a good human being.

I feel lucky to be alive. Don't you? That is part of being a mature person—appreciating the little things that bring us joy and knowing where to look for them. No, I am not talking about that sugar rush we crave midday; I am referring to trickles of small pleasures, flows of bright lights, delighting in a moment and relishing in a success. It's about finding happiness and complete bliss in small doses like a vitamin we take every day.

We sometimes look for happiness in all the wrong places, like at the casino, or via the latest product that will remove wrinkles or stretch marks, or through a piece of chocolate cake.

I find happiness in optimism about the future. I find it in my nephew's smile, my niece's innocence, in the peace I feel when I wake up every morning looking at the lake behind my house. I find it in my sisters' laughter on a Sunday night when we're eating dinner and catching up on the week. I find it in my childhood memories of life with my dad, like when he took us

to get Stroh's ice cream or just for a ride to talk.

I knew I had become a woman when I realized life is a gift, even though not everything we experience in this life will be fair.

~

I Knew I Was a Woman When… I realized for the first time I was not a victim; I was a survivor.

It was October 1991. I had suffered abuse as a child from my stepfather. I carried that load for so many years, thinking it was my fault. I always felt the world was against me and that I was being attacked. It wasn't until I was 45 years old that I realized it wasn't my fault. I decided to get help. I went through some intensive therapy. I found out that a lot of girls who were abused thought it was their fault. It was then I became a woman. —Jacqueline Shellman

~

I Knew I Was a Woman When… I realized the water would always be hot.

When I was a little girl, all I wanted to be when I grew up was my mother. I wanted red lips and fingernails. I wanted full skirts that swished when I walked. I wanted to be charming at parties and admired for my social graces. I wanted to smell like Chanel no. 5.

When I got a training bra at the age of 12, I knew I was on my way. I was proud of my budding body, eager to join the sisterhood of women.

But the more I blossomed physically as a woman, the more I got a sense of my lesser place in the world—a burden I hadn't suspected would come along with the privilege of wearing high heels and makeup. Suddenly, it wasn't proper for me to hang out with the boys or to wrestle with Daddy. I wasn't expected

60

to play sports, but to cheer the boys on to victory. It seemed that I couldn't have a date and a mind of my own, too.

I began to think of womanhood not as a blessing, but a burden; something that had to be overcome before I could realize my full potential as a human being. *My 20s were spent trying to reconcile my strident insistence on equality with the world's insistence on me becoming a helpmate, a nurturer, a supporter of others.*

Marriage and motherhood only increased the tension I felt between my goals as a person and my role as a woman. Motherhood forced me into less challenging jobs, positions I took in order to be able to shoulder the onerous responsibilities of parenting. I had not expected that so much work would automatically fall upon my shoulders without being negotiated. It was assumed that I would be the keeper of the home fires, regardless of whether I felt a natural inclination to do so.

I had gone from law practice to more 9-to-5 hours so that I could be home regularly. My husband worked harder to make ends meet, often leaving me to care for the home and family while he advanced at work. Every aspect of my personality was subsumed by the greater needs of the family. I became under-stimulated, isolated, depressed and overwhelmed with the mundane aspects of homemaking.

But after five years of baby bottles and strollers, my kids were finally becoming more independent. I dared to think about what I WANTED to be, instead of what I HAD to be simply to survive those tough years as a new mother.

In those days, we were living on a shoestring budget. I had grown used to denying myself life's little pleasures: haircuts, new shoes, a set of matching dishes, a quiet dinner in a restaurant. But there came a moment in 1992 when I decided that getting a computer was not a luxury item or a frivolity, but a lifeline. I needed to feel like my endeavors to ensure the survival of my family would not ensure my own death as a person. I needed to write.

When the computer came in the mail, my heart throbbed. I wept before I opened the box. As soon as I plugged it in, I sat and I wrote. After that, I wrote in the middle of the night or early in the morning. I wrote with children on my lap. I wrote for therapy, I wrote for fun, I wrote for exercise, I wrote for revenge.

And that's when I learned what it means to be a woman in this society. To be a woman is to be entrusted with creating life itself. If we can do that for others, we can do it for ourselves. I began to see everything that I did—every diaper change, every parent-teacher conference, every soccer game—as fodder for my own journey as a person and a writer. My life as a nurturer began to nurture my life as a writer.

When I stopped seeing my roles as a mother and a professional as oppositional, they started coming together in unexpected ways. It wasn't long before I was freelancing, then working as a columnist, winning poetry contests, and exploring opportunities in radio and television—all based upon my experiences as a woman.

*It was once said, "A woman is like a tea bag—only in hot water do you realize how strong she is." That's when I became a woman. When I realized that the water would always be hot, and that my life's challenge would be to steep in it, until the flavor was right. —**Desiree Cooper***

~

__I Knew I Was a Woman When...__ I realized I had to accept life for what it is.

I'm not sure I know what a real woman is. I know what television says, the world and my momma says, but I'm not real sure. I do know that I got some real freedom about who I was in 1992 after I did the workshop called the "Forum." I got to see how I came to be who I was and what shaped my thoughts, my values and my behaviors.

Getting to the source of a lot of "stuff" gives you the freedom to choose something instead of something choosing you and having its way with you. I learned how to forgive, say I'm sorry and let my father off the hook for my interpretation of who he was. It was a vehicle to get to the good, the bad and the ugly about myself.

It allowed me to be responsible for my life and not be a victim. Perhaps being a real woman lies in responsibility. Being responsible for whatever hand you're dealt. Making it work or not, yet being responsible for that, too. I guess I became a real woman when I realized: "Hey, you've got what you've got—get over it and get on with life." —**Charilyn Hackney Goolsby**

~

I Knew I Was a Woman When...my mom died.

When I was 17, my mom died of cancer. I realized really bad things happen to good people and I would have to learn how to cope and move on. —**Patti Alef**

63

Free yourself by accepting life for what it is—here is another "SitChat" topic:

- Write down all the things you want to change.
- Write down how you are going to change the things you can.
- Cross out the things you cannot change.
- Replace the things you cannot change with a list of things you are grateful to have.

On My Own Now

I don't know if I have ever felt truly independent. I need people. It's part of my makeup. I just can't be alone. Someone once told me that if the world was destroyed and he was the last person left on Earth, he would last about 30 minutes alone and would inevitably do himself in. I feel the same way.

Of course, many women feel differently.

It was the moment she felt independent from a man when she felt like a woman. She knew at that moment when she had emerged into adulthood, not needing the support of another human being—that she had become a woman.

But my independence came when the strings attached to my father had been broken. I felt truly alone. I was relieved by his death but scared of my own independence. Ironically, the moment I felt like an adult was when my dad died.

I awoke suddenly just before 5:00 a.m. on Thursday, January 10, 2002. I had fallen asleep in the guest room that night because I didn't expect to really sleep. I had lain down to rest and I dozed off for about two hours. I woke up abruptly, as if late for work, and looked at the clock on my cell phone. But I was not late for work. I woke up that morning so suddenly because I knew my father had died. I looked at the time and silently said to myself, "Dad's gone."

And I was relieved.

It wasn't because my dad died that the stress was lessened; it was because I knew he was no longer in pain. I knew I

wouldn't be pained myself hearing him agonize about his back and his internal bleeding. I knew that he would no longer be hooked to IVs and blood transfusions and a morphine drip. His suffering was over.

About a half-hour after I woke up, the phone rang. My sister Suzanne called to confirm what I already knew—my dad had died shortly after 5:00 a.m. She told me to wake up my sister Shanna and come to the hospital. I walked around my house and I could feel him watching me as I got myself ready to go. I felt him as the tears came down and I sobbed like a baby. I had known that day would come, but I had no idea how I would feel until that moment. As I cried for the man whom I could no longer see in human form, I knew the spirit of the man was now in a better place.

Although I am the older sister by nine years, Shanna drove to the hospital and begged me to stop crying. But I couldn't. I thought about the last two hours I saw my dad alive. He lay in the hospital bed barely able to speak, drugged on morphine. The last words he whispered, as he looked me in the eyes, were, "I love you."

I replayed that moment over and over in my head. I had feared the day my dad would die, but he left me with the one thing he could leave me with. I wasn't really alone and I knew it. I had his love.

As I walked through the hallways of the hospital that morning there was a silence I hadn't heard in the twelve days my father was there. The woman four doors down was no longer screaming that the hospital was going to kill her. I didn't hear the Italian woman across the hall gagging every two minutes.

As I approached my father's room, the silence grew "louder." I strained to hear the machines pumping as they did for so many days, but they had been stopped and my father lay lifeless on the hospital bed.

I held his hands, which were still warm, and I stopped crying. I realized something at that moment.

The presence of my father I had felt so strongly in my home just 30 minutes earlier was not in that room. He was gone and what was left was this body that had failed him.

I never thought that through death one could be awakened. I am still learning something every day by the loss of my father. He left behind a legacy I didn't expect. I always believed my father was a wonderful man, but I was biased. He was my father, after all. What I didn't know is how many lives he had touched.

More than 5,000 people walked through the Yono Southfield funeral home in the two days of visitation and nearly 1,300 people attended the funeral mass. I was worried that my father's life would go unnoticed because he didn't die a famous man or a rich one. But my father left a mark on this earth that was more profound than stories could tell and money could buy. He left the legacy of what it means to be a good man. Obviously, so many people realized the importance of that.

As I watched through the window of the limousine the processional line leading to the cemetery, I knew my father had made a difference in this world.

And again, I was relieved.

I was relieved because I knew he had given me the strength, courage and love I needed to make it in this world as an independent woman. He told me I could be anything I wanted to be and when he died, I finally believed him.

While it was death that elevated me to a level of adulthood I had never felt before, I realize independence itself defines womanhood—independence from a man, from your parents, from a family business, from your siblings or from authority figures. You are your own person separated from anyone else. It's not that we as human beings don't need one another; it's that we need to feel independent to truly be recognized as an adult.

~

I Knew I Was a Woman When... *I picked up my clothes from the dry cleaner for the first time.*

I moved to Chicago from Detroit and got a job at a real estate company in the John Hancock Center. I remember the first time I felt like a woman, or maybe just a grown-up, was when I picked up my clothes from the dry cleaner. As I walked down Michigan Avenue with the hangers and the plastic bag of clothes over my shoulder. I thought, "Today, I am a woman." I didn't know what it was about the clean clothes in a bag. I had paid for them myself. I didn't wash them in a dorm. I had my dry cleaning and I was a woman. —**Rose Abdoo**

~

I Knew I Was a Woman When... *I moved to New York to pursue acting.*

I really became a woman after I graduated from college and packed up and moved to New York to be an actress, which I was before becoming a sports announcer. I was terrified. My family and I are very close. I grew up in a time when my parents said, "You are going to college and when you are 21 you can do what you want." So I did. I packed up and went to New York. I didn't know anybody. I got an apartment and started going on auditions. There indeed was one time when I got home in that little hovel of an apartment and said to myself, "You are a grown-up now." —**Suzyn Waldman**

~

I Knew I Was a Woman When... *I realized there was a difference between men and women.*

I don't know the exact moment. It's not so much when I became a woman as it was when I was finally aware there was

68

a difference between men and women. I was in high school, around 16 years old, and I noticed that if anyone talked about my brother's plans for the future it was always college and what his career was going to be. If anyone was discussing my future or any other female's future, it was basically; "You are going to college to find a rich husband."

For my brother, it was about his grades and extracurricular activities, and for my sister Colleen and I, it was about which beauty pageant we were we going to be entered into and how we could be homecoming queen. At the time I resented it. Beauty pageants were demeaning and self-worth was based on what you looked like and if you answered the questions properly. Were you the perfect little female? Since then, I have grown up and realize everyone's different. I can't watch the Miss America pageant but I know some women enjoy that. I know now that regardless of what others feel or think, I have the right to feel and think the way I do. —**Sherri Robinson**

~

I Knew I Was a Woman When... *my husband was killed and I had to plan a funeral.*

My first husband and I were both 26 years old and had a 2-year-old son when I realized I was a woman. We had just purchased a wonderful new home and were making plans to have a second child. We were also making time to enjoy life more with hobbies and friends. I took up bowling and he took up something he had wanted to do since his return from Vietnam six years earlier—skydiving.

On his second jump, his chute malfunctioned and he was killed. When the sheriff left our home after informing me that my husband was dead I became an adult instantly. I now had funeral arrangements to make, a house to maintain and a son to raise on my own. When I walked into the funeral home and picked out a coffin for my 26-year-old husband, I knew that

there was nobody to take care of me anymore. I was an adult, a woman, not just someone's daughter or someone's wife or a little boy's mom. —**Sheila White**

~

I Knew I Was a Woman When... *I made my first dinner in my very first apartment.*

My mother was an old-fashioned woman who always made dinner while my father waited at the table. I was under my mother's wing. I remember I walked into my apartment and made dinner for the first time for myself. I looked around and realized everything was my own. There were things I had created myself.

I didn't have a lot of money, so I made furniture, and it was like, "This is who I am." I was 17. I was cooking fish because I never got fish at home. I felt like I could do anything I wanted to do. I remember thinking that my mother and father didn't define me anymore. I was becoming my own person. My apartment was a mixture of masculine and feminine things and I remember thinking, "This apartment is an extension of me. I am my own woman now."

Even though I felt like I was a woman at that moment, I didn't become a whole person until years later. I spent 27 years addicted to heroin and lived a life on and off as a $5 dollar prostitute on the streets of Detroit.

I was a violent drug addict, in and out of jail. I went through 14 rehabs before I was able to become drug free. I hit "rock bottom" when I woke up in an abandoned building in the Cass Corridor district of Detroit next to some guy who I didn't know. —**Sarah Dean**

~

I Knew I Was a Woman When... *my dad and I had a huge disagreement and I stayed calm.*

I was 31. It was the beginning of a decade-long lesson in standing up for myself, as myself. And in seeing others as individuals, realizing that blood relationships did not carry the power to dictate and that a disagreement (even many disagreements) weren't the end of the world. —*Peg McNichol*

~

I Knew I Was a Woman When... I had become a professional athlete.

In 1988, I had signed with the Dallas Diamonds. I had been running around and having fun in college and all of the sudden I was a professional athlete in basketball making a $100,000 a year. I felt like, "Boy, you do grow up." There are a lot of responsibilities that go along with that. I was 22 years old. —*Nancy Lieberman*

~

I Knew I Was a Woman When... I realized a woman is humanity personified.

The first time I felt that I was truly a woman was during the Elian Gonzalez saga. Remember when the Cuban government sent his two grandmothers to the United States to retrieve their grandson? They offered nothing legally or intellectually. They depended on humanitarian aid. At that point, I realized something invaluable to my own human spirit—a woman is humanity personified, and therefore her benevolence supercedes laws made by man. It was at that point that I realized that I, as a woman, have powers beyond any given human status. —*Nicole Rashid*

~

I Knew I Was a Woman When... *I told my mother I was divorcing my husband.*

It's funny because marriage, for most people, would be a sort of coming-of-age experience, but for me it was the divorce. It seems that a lot of people measure their adult status in the eyes of their parents and that is definitely the case with me.

When I first told my mother that I wanted to divorce my husband she said all the things I expected her to say—I was selfish, rushing into things, immature, didn't know what it took to make a relationship work, etc. But I had already made my decision and told her that it didn't matter what she thought.

I did want her to understand why I was making this decision so I explained to her all the things that were wrong in my marriage and confided in her as I would a peer, and that made all the difference. After hearing all I had to say she agreed with my decision but the leap to woman came from us both knowing her agreeing didn't matter. —***Karla Longtin***

~

I Knew I Was a Woman When... *I went to Europe.*

I think the first time I realized I was really on my way to becoming an adult was when I was studying abroad in Europe. It was during the summer before my junior year in college. I boarded a flight to Germany and was likely the sole American in the cabin.

It was quite an experience. We had an unscheduled stop in a small German city and we all had to get off so they could check the plane for something or another. Since I don't speak German, I couldn't understand what was happening. The flight attendants gave directions in German first, and then in English, but by the time they started giving the directions in the language I understand, people were milling about and talking to each other and I couldn't hear what was going on.

It was pretty distressing. We had to leave our belongings on

the plane but I didn't know if or when we'd be getting back on board. That was one of the first times I really felt I was on my own. I had no one who cared, no one to turn to—my parents, family and friends were all thousands of miles away.

I guess I may be overdramatizing that moment, but it was the start of a two-month adventure with dozens of similar situations in which I underwent a period of transition from being just a kid in college to somebody ready for whatever obstacles came her way. **—Katherine Leslie**

~

I Knew I Was a Woman When... *I made the decision to join the Iraqi Kurdish opposition in 1982.*

In order to understand why this was such a revelation for me, you must understand my history. As an educated woman, I became the advisor and counsel for Kurdish women in the mountain region where life was rough and primitive, and where underdeveloped, naïve, simple people lived.

My involvement with Kurdish opposition and my position became known to thousands of people. I feared for my life. The news of my arrival in Kurdistan spread, and to have a woman with a Ph.D. join the opposition was a big deal. The Iraqi government took this seriously and pursued my family and me.

I worked with the Iraqi Kurdish opposition from 1982 to 1989. I began writing down my experiences and before I knew it, I had a book. I was injured by the Iraqi government's chemical and biological weapons and suffer the effects today.

In August 1988, the Iraq-Iran war ended and Saddam Hussein directed all his troops to crush the Iraqi opposition, showering the Kurdistan region in the northern part of Iraq with chemical and biological bombs and forcing over one million Iraqi Kurds to repatriate to different countries. I was among those who fled Iraq at that time.

In September 1988, I crossed the Iraqi borders to the Slopia

Camp in Turkey. In Turkey, we feared the government, which had a problem with the Kurdish movement as well. In April 1989, I fled to Syria on foot.

Later that year, I went to Algeria and started working for Agronomy Institute. Unfortunately, from the first day in Algeria, I started dealing with harassment because I was a Christian and non-Arabic woman. I faced intimidation and threats from the Islamic Fundamental terrorists. They stormed my house in the middle of the night to kill me. I fled from the back window. They looted my home and left a message: leave the country.

From Algeria I fled to Bulgaria to save my life. I could not find employment. I went to Russia so that I could eventually seek asylum in Europe. Smugglers took advantage of me and I was forced again to return to Bulgaria. When I returned, I faced new problems—I was illegally there.

*The Iraqi embassy was very strong in Bulgaria and one day agents of Saddam Hussein attacked me in my house. My life was in jeopardy and I had to flee Bulgaria. I went to Romania with the intention of going to any country that would give me asylum or at least temporary protection, but again I was forced to return to Bulgaria. I couldn't stay, so I crossed the Greek borders by foot. I got asylum and was granted a refugee status. I was a free woman. I was my own woman now. —**Katrin Michael, Ph.D.***

~

I Knew I Was a Woman When… *I saw a captain lying dead on the street.*

I was 14 years old when I saw a captain of the Greek resistance who fought against the Nazi occupants lying dead on the main street of my neighborhood. Before being killed, he and his comrades were stationed in our house. I admired him for what he was, without realizing that it could also be

74

admiration of a man who was a fighter and at the same moment educated and extremely handsome. I realized that when I saw him dead.

I ran to his breathless body and kissed the frozen blood on his temple. I saw the garbage collector throwing him in a horse drawn carriage and I instantly knew that he would be buried without being mourned.

My heart ached for the loss. I considered him as a hero and heavenly beautiful and, as such, he should not die. **—Ionna Karatzaferi**

~

I Knew I Was a Woman When... *I traveled to Toronto by myself in 1996.*

It was just me, myself and I. I ate alone; I rode the subway alone; I attended a play alone; I slept alone; I walked through the city alone and I spent quality time alone. I spent four days by myself. This was a time of peace for me. I had never been on a vacation completely alone. During that time, by myself, I reflected on who I am and I realized at that moment I became a woman. **—Yvonne Harper**

~

I Knew I Was a Woman When... *I was 9 years old and became the woman of my household.*

I felt like a woman or adult early in life. I always felt different and I always had men around me. I felt like an adult when my father came back from prison.

My mother decided to give us up, because she was in love with another man. She left and I stayed with my father who at the time was a stranger to me. He was arrested when I was 4 years old, just after the Civil War in Greece.

When my father came back from prison, I remembered him

but not much. When I stayed with my father, I was my sister's mother. She was 7 years old. It was 1952. I was responsible for my sister and for my father. I washed his clothes. I was responsible for everything my mother used to do.

*I was also responsible for myself. I had to go to school. All this responsibility made me feel like an old woman even though I was just 9 years old. —**Maria Piniou Kalli, MD***

~

I Knew I Was a Woman When… *I became the head of my family.*

*This is interesting to reflect on. I am a late bloomer. I was 32 years old. It was probably 1969. I became divorced and took responsibility for the family. At the time, I had six kids ranging in ages between 3 and 11. The reason that was my defining moment was because before that, I let other people and things define me—my environment, society and by people around me. At that moment when I took over the family, I became a whole person. —**Joann Castle***

~

I Knew I Was a Woman When… *I was being responsible for others, not just myself.*

And, when I learned to use my charm to influence a man's opinion. This was no easy task for a woman in a wheelchair.

When I was 16 years old, my life changed within a split second. A bullet severed my spinal cord and I went from being an independent, active, energetic and happy teenager to a quadriplegic dependent on others to take care of me. I didn't see any value in living.

I was suddenly a burden to the people I loved. I couldn't do anything for myself or help others. I needed help to brush my teeth, put socks on and do my hair, and living seemed more a

waste of others' time. Worse, my personal care was not covered under my health insurance and I began costing my family a great deal of money, time and trauma as they integrated my new personal and medical needs into their lives.

My story is like so many people living with severe disabilities. Now years later, I recognize how fortunate I was to have a family that refused to give up on me. My mom put the same demands on me as before I was paralyzed.

She expected me to continue my education, regardless of whether or not I was having a bad day, and she pushed me to continue on each day. Over time I was able to stop feeling sorry for myself and continue a path similar to before my accident. I derived great strength from the stability of my mother and younger sister who, without hesitation, would drop everything to assist me.

Without a second thought my family would be there, getting me to where I needed to go, including many high school and college classes.

At the time, I thought it was ridiculous. What was I going to do with an education? I thought I had no value. I was fortunate to graduate from both high school and college. I couldn't recognize at the time how instrumental it was to have people in my life to direct me.

I was in such a state of unbelievable loss and pain. I didn't know how to cope. But over time, a pattern occurred in my life, and the more people gave of themselves the more I could give back. The rewards of others' selfless, unconditional love does make a difference.

It was the love and strength of others that has given me the power to achieve beyond anything I could have dreamed of. The more I achieved the more I realized I could achieve and, ultimately, help others less fortunate achieve. I feel such an incredible need to do whatever I can to improve the opportunities of others who have similar circumstances. I am blessed and intend to help those so the rewards and cycles of

helping others go full circle.

I am especially committed to helping the tens of thousands of young people with healthy minds and spirits get out of nursing homes and benefit from all life has to offer—a job, home and education.

I continue to see that the more I give, the more I get. I received a great deal of support from friends and family and had resources that a great majority of people with disabilities never get. None of this would have been possible without the assistance of others.

Sometimes it was my mom, other times my sister, or a personal caregiver, or friends, or my brother, but always it was with the assistance of another. It didn't matter how strong my will was, I could not accomplish my goals, including the simple tasks of getting out of bed, picking up a phone or taking a drink of water, without the assistance of another human being.
—Heidi VanArnem

~

I Knew I Was a Woman When... *when I bought my first home.*
I think I first felt like a woman when I bought a condo at the age of 35. I say that because that's when I felt really empowered. I proved to myself that I didn't need a man to take care of me—I could do anything on my own. **—Anne Miller**

~

I Knew I Was a Woman When... *I bought my first car.*
At age 25, I bought my first car all by myself. I was still in graduate school, I didn't have a job, I was supported by a fellowship and I didn't have credit, but I was able to get an auto loan (and insurance) for a brand-new car without a co-signer! I must have looked like a "real person," not some kid

who needed supervision or backup. It was pretty special that the first car of my own was the one that I bought. It signaled my ability to take care of myself. In my mind, that's what adults do; they are capable of taking care of themselves. Being a woman meant first and foremost, being an adult. —**Debra Ann Brodie, Ph.D.**

~

I Knew I Was a Woman When... *I went to college—so I thought.*

My idea of what it really means to be a woman is so different from when I was growing up. I was raised in the late 60s and early 70s, and early on I was very influenced by the feminist movement and thought that being a woman meant you didn't need anyone but yourself. So I think I first believed, though falsely, that I had achieved womanhood when I went off to college on my own and then when I got my first job as a radio news woman after graduating from college in 1981. My career was my life and I made no bones about the fact that I put my goals first. Even when I met the man I would marry, I told him in no uncertain terms that I was a career girl and that no man was going to stop me from pursuing my dream of becoming a broadcast journalist. I was blessed to find a guy who was so supportive and who stuck with me despite my selfishness. —**Teresa Tomeo**

~

Having been thrust into womanhood by getting married and having my first child at age 16, I got blocked at the concept of ***"I knew I was a woman when..."***

For me, I knew I was alone; I knew I was responsible, and I knew I was depended upon at a very tender age. It was not a happy time in my life. Very lonely. Very confusing. I'm sitting

79

here thinking, "so when DID I know?" and I still draw a blank.
—**C. Leslie Charles**

~

I Knew I Was a Woman… *when I figured out no one in the whole world loved me and I had to love myself.*

I lost my mother when I was still young. She started getting sick when I was 8 years old. I was floundering out there, because I had no guidelines. I experimented with being a woman in many different ways—sexually, independently, going against my father and being a rebellious kid. I was growing. I was trying to figure out how I could become a woman. My mother died when I was 14 and my father died a year later in an automobile accident. My mother had Alzheimer's. She was only 44 years old.

I saw this woman who my father adored; he did not want to take her to a nursing home. She lived with us until the day she died. I lived in a home that smelled like a nursing home. She was like a vegetable in the end. She slowly lost her speech. Then she couldn't walk. We had caregivers living with us continuously. It was as if I was raising myself. I was looking at the world. I was learning just by looking at the world and experiencing things. This was difficult.

I was almost thankful when she died, because it was a horrible way for anyone to live. I discovered, at a very young age, how important a quality of life is. I became an orphan at the age of 15 and a ward of the court when I was living in Hollywood, as a child actress. I had no family there. The court thought it was in my best interest to send me to a little town in Missouri called Osceola to live with my dad's brother.

There were 900 kids in my high school class at L.A. High. When I got to this little town there were 800 people in the whole town; I had a cultural shock beyond anything I could imagine. I was thrown into a class of 20. They were all farm

I KNEW I WAS A WOMAN WHEN…

boys. *I was also put into an unhappy home life. I lived with my uncle and his wife. I learned right then that I had a wonderful support system up until then—my parents gave me so much with the love they gave me. I think that was the moment I figured out no one in the whole world loved me and I had to love myself. I had to be a woman and I loved being a woman. Now is the time I had to make my choices.*

I prayed every night that I wouldn't turn out like my aunt. You are so vulnerable and impressionable as a teenager. There were times I was raising my kids and I saw her come out in me and I would back off—fast. I think it was a good thing what happened to me because it taught me compassion for other people. It also gave me the opportunity to open up. The whole town knew what my aunt was about and I got so much love and support from all the people in that town—from the merchants and teachers. They gave me love and I knew they cared. I was never exposed to that in California. It was a gift to me. It made me realize that I didn't want to go back to California. The people in the town gave me a wonderful gift by showing me that there were other things in life. I wanted out of the situation I was in and I got an education. It was my way out. I became a medical technologist. I had to feed me. I did it for 20 years. I left music and drama. It was a conscious choice I made.

I didn't realize that you made choices until then. I had lost my friends because my aunt made me cut off all communication from anyone I had ever known. I was really alone. I knew then, that was the moment I had become a woman. **—Karolyn Grimes**

81

More "SitChat" discussions: Ask Yourself...

What can you do today to become more of your own person?

If you don't feel independent, make one change that would help. For instance:

1. Live on your own
2. Pay your own bills
3. Get a job
4. Buy your own car without the help of someone else

Still On My Journey

Through every experience, I become more of a woman. Just like the caterpillar transforms into a butterfly, we as girls do the same. Some women may experience a certain moment like a revelation, but we evolve into women, into human beings, into ourselves and into our individuality through significant moments.

I have many of these moments.

~

I Knew I Was a Woman When... I saw myself through the eyes of someone else.

I had dated and was infatuated what seemed like a million times over the years, but it wasn't until I truly cared for another person unconditionally that I felt like woman.

My first "boyfriend" was my neighbor. He lived across the street to the left. We were just best friends at the time. I was 12 years old and just starting to look more like a "woman." My menstrual cycle had started and I had replaced my spaghetti-strapped undershirts for training bras.

I felt like a giddy girl, but a sense of womanhood came years later.

My father caught us kissing in the garage. The lights were off, we were sitting on the tractor, and he came over to show

VANESSA DENHA

me something he won during a hockey game—the love
exchange of adolescence.

Not really a true meaningful relationships, considering our
dates consisted of playing basketball and skateboarding around
the neighborhood.

It was my first true friendship with a man that made me see
myself for who I really was for the first time. I met him on
Christmas day. We met through a mutual friend and when he
shook my hand, I knew that he would change my life. The
relationship lasted awhile and it was the first time in my life
that I learned so much about myself. It is amazing how much
you see yourself through the eyes of another person.

He became my best friend for that period of time. Until I
realized that there was someone else out there for me. God had
someone else in mind. I knew I had become a woman when I
got the strength to give him up with the thought of perhaps
never finding anyone else. I knew he wasn't the right person
for the rest of my life. He was Mr. Right for the moment—and
the moment had faded.

~

I Knew I Was a Woman When... I learned to stick up for
myself for the first time.

I was picked on a lot as a kid. I was teased and taunted for
my curly hair and chubby body. I believe that becoming a
journalist has helped me stand on my own. You must build a
thick wall of skin in this business just to survive, let alone
succeed.

One year I was covering an annual conference in Northern
Michigan. It was the "who's who" of the state. Once, during an
interview, one local politician patted me on the head. The
empowered journalist reverted back into the pigtailed girl. In
one motion, he diminished me, but only for a second.

I lifted my head up, held the microphone a touch closer to

84

his mouth and said, "So, what are you going to do about the increasing crime rate in Michigan? Detroit still has one of the worst images in the country."

During a barricaded gunmen story, where I had just spent several hours in the cold rain, a local law enforcement official called me the "little radio girl" in front of a pack of other journalists while conducting a live press briefing. Becoming a confident woman is having the ability to rise above those moments.

I also discovered in the workplace that women tend to tear each other down instead of lift each other up. This surprised me. I come from a family of women, although we had our share of disagreements, mostly fighting over the bathroom or clothes, we never demoralized one another. Women tend to be petty. I have been the victim of jealousy more times than I wish to remember. It takes skill to be able to defend yourself without getting caught up with the jealous rivalry.

Every friend I have in the media has a story she can tell of how a female coworker has gone to great lengths to sabotage her work, or tarnish her image. Jealously is an evil emotion that breads hate. For some women, as they grow older, their insecurities sometimes seem more apparent.

~

I Knew I Was a Woman When... I was able to accept my parents for who they are and love them unconditionally right back.

At some point or another, we have all felt embarrassed by our parents. I remember one of the most horrifying experiences of my childhood was when my mother served as lunchroom monitor. She did this often, as many parents did.

We attended a Catholic school and as a means of saving money, parents served as lunch monitors, rotating every several weeks. My mother volunteered often. One day, in the fifth

grade, my mother was joking around with the kids in my class and I wasn't paying much attention. I was trying to ignore the fact that she was in the classroom. It was already difficult to blend in when your mother had a heavy Middle Eastern accent and you spent most of your time explaining what she was saying.

A kid got hurt in class and my mother's maternal instinct kicked in and she kissed the kid's "boo boo." I was horrified. He was 11 years old at the time. His own mother probably didn't kiss boo boos. Plus, he was a boy. My mother never had sons. She was accustomed to pampering seven little girls.

You know that you have embarked on adulthood when you are able to not only accept parents' idiosyncrasies and embarrassing moments, but be proud of them as well. As I grew older, I slowly began to realize how difficult it must have been for my parents, being foreigners to this country and raising seven American daughters.

They adapted well.

They educated themselves, read current event issues and kept abreast of what was going on in the world. They assimilated into this country but were still able to teach us the customs of our own culture through rich ethnic food, uplifting music and speaking Aramaic at home.

So many other women are on the same journey.

~

I Knew I Was a Woman When… ALWAYS.
*I always knew I was a woman, but I knew it even more when I had my first period. I thought I was going to have it all my life, and I did not feel any joy. I would hide it. I believed I was sick—that having the period was a sickness. When I was growing up during those years, to talk about that with your mother was "taboo." Nobody would dare to talk about that with their parents. —**Mercedes Sosa***

86

~

I Knew I Was a Woman When... *No event would totally typify that moment of glory...I'm just not there yet.*

I grew up as an overindulged, creative only child with a doting father and an overbearing and nagging mother. My childhood was mostly pleasant in childhood fashion and I seemed not much of a child, even during those early years.

Often shipped off to New York to visit my wealthy and vodka-reliant aunt, I spent hours on the streets of Manhattan alone, making acquaintance with the street vendors and eating interesting treats from their usually steamy carts. I enjoyed my freedom and my ability to handle oneness with such finesse.

My teenage years were typically turbulent and overly emotional, mostly due to the emotionality of an unhappy mother. Add in a mix of liberalism and parental trust, which gave me a wide birth of freedom—and freedom I had.

My tastes and interests were quite different from my parents' but they both made every effort to see that my interests were fueled and my tastes accommodated.

I couldn't wait to escape the household and found myself in a relatively early short-lived marriage as a result. On becoming a woman, I could say the typical trite responses of "a first kiss," "losing my virginity" or "giving birth"—none of which would totally typify that moment. Maybe that perfect moment of womanhood was truly falling deeply in love—finding your soul mate.

Where the road leads? I'm still waiting for that moment of glory—I'm just not there yet. —**Ruth Mossok Johnston**

~

I Knew I Was a Woman When... *I realized I was wrong about what I thought it meant to be a woman.*

There were a couple of times in my life when I felt like I had

87

become a woman, but I feel that neither were really it. One time was when I had first gotten my period. I thought to myself that I was such a woman because I was going through puberty. Another time I felt as if I had become a woman was when I had first had sex—losing my virginity. In actuality, I think I became a true woman recently. Now that I can care for myself financially, without the help of my father, who has been there for me every time I needed help with money. —Anna Marie

~

I Knew I Was a Woman When... *I realized we evolve in different stages.*

My mother would tell that I was born thinking I was an adult. I was always a girl's girl. I don't know if I feel any more of a woman today than when I was 10. I think we evolve in different stages. I think now I feel more childlike. I say, "Wow! Look at what I don't know." When I was a kid I was into dressing up. People would sometimes describe me as a Jackie O. I was wearing the satin gloves. I was always into the girl piece of life. I always wanted to be an adult. I think I was born being a woman.

Now, as an adult, I think I am still a girl. There is that little piece of you when you are feeling sick—you want your mom to come over and make you chicken noodle soup. You want your dad to put his arms around you and tell you that everything is going to be okay. I don't know if that ever leaves. The little girl is still there even though now I am in an adult body. —Pam Johnson

~

I Knew I Was a Woman When... *When I gave birth. When I got married. When a young woman called to ask about career advice. When a four-year-old in the neighborhood asked,*

"Mrs. Osborne, can I have something to drink?" When I had to stand up and speak my mind against some obvious sexism in the office. When I made the toughest family recipe all by myself for the first time. When my intuition kicks in, and I know a story is worth pursuing.
There were, and continue to be, so many moments.
*Being a modern woman is a work in progress. In my 20s there were so many opportunities to take advantage of, in my 30s it was a time to watch the miracle of my family unfolding, and in my 40s it's a sense of freedom and confidence. And when I see my friends vibrant and fun loving in their 50s and beyond I think, this could be just the beginning! —**Marie Osborne***

~

I Knew I Was a Woman When… *I realized becoming a woman is a process.*
I don't remember one moment when I suddenly felt that I had become a woman. I think becoming and being a woman or a person is an ongoing, lifelong, evolving process. I have always felt like me: simplistically put, an introverted, energetic and creative person. I do, however, remember feeling very female being pregnant (all three times); going through the process of giving birth, and also when I tried to nurse my first baby, even though it didn't take.
*I don't define myself by my gender. I grew up in the 50s when women and women's lives were very restricted, and defined by others. Today, with a woman's body, mind and spirit, I can weld steel, build large-scale steel sculptures single-handedly, and feel strong, innocent, empowered, knowledgeable and vulnerable, while simultaneously being a mother and grandmother. —**Lois Teicher***

~

I Knew I Was a Woman When… *I got my first bra, when I got my period and when my mother died. I became more of a woman each time.*

This is a threefold answer. I threw this question out to other women to get their input. Usually it seemed as though their moment was marked by a strong juncture in life—menstruation, first kiss, first sexual encounter, marriage, etc.

For me, three episodes stick out, two in which I was deemed to be a woman and the third in which I HAD to become one. The first was when my mother informed me that I was a young lady and had to wear a bra. This did not sit well with me, the tomboy that I was. The doggone thing was so uncomfortable (training bra!) and I kept tugging down on the stupid contraption. It was an intruder into my life and simply did not belong. After all, boys didn't have to don these straps. Why should I? Of course, now I'm grateful after 35 years of constant bra wearing. Yes, I sleep in it too, most nights. And I didn't abandon my bra in the freewheeling 70s. My breasts are thankful for my "support" all this time. They haven't seen too much of the effect of gravity—at least not yet. Hopefully, they won't.

The second moment of womanhood—according to Mom—was the day I got my first period, around age 12. She marched me into the living room and in the presence of my three brothers loudly and proudly announced, "Your sister is a woman now. Treat her nice. She just got her period." Oh my. I don't remember much of what happened after that because I was in an embarrassed shock. One day I'll have to ask my brothers if they remember that moment as clearly as I do. If so, what did they do? Probably plotted to taunt me the rest of my life.

The third moment occurred when I was 28 years old. After a fairly long illness, my mother died from congestive heart failure. Hers was the first "close relative" death I'd ever experienced and it hurt. She was 67. My dad was also 67 and

was now alone after nearly 34 years of marriage. When she died, I felt as if I had to grow up overnight. It's not that I wasn't on my own, as I had married two years before. And it wasn't as if I had never had responsibility, because as a working wife, I did. But, for some reason, I suddenly felt I was alone. I was the only woman left in the family and my dad needed me (or so I thought). My brothers did too, though they were all marred with kids then. It was almost as if I could never truly "Go back home" again, at least as I had always known it. —**Janina Jacobs**

~

I Knew I Was a Woman When... *I realized it was a process.*
I thought about this question for a long time. While all indications are that I am, in fact, a woman and an adult, I'm not sure at what point it all happened, which makes me consider that I might still be in the process of getting there. I feel as though I'm still a "work in progress" and the journey is far from over. There's so much learning to do and experiences to have that I still feel like a youngster in so many ways. So, for me, becoming a woman happens a little bit at a time...just one very interesting lifelong project. —**Ann M. Delisi**

~

I Knew I Was a Woman When... *I started high school.*
It was a new stage in my life and it made me feel like a woman. I was excited and there was this new world around me. It was the start of a new chapter in my life. I was becoming an adult and I continued to feel more like a grown woman with each new chapter: when I graduated college, got my first "real job," got married and became a mother. —**Jennifer Thomas Abbo**

91

Don't compare yourself to people who have more than you because in life there will always be someone smarter, prettier, funnier, wealthier and happier. In life, compare yourself to those who are less fortunate. It is then you will appreciate what you have. —**Sabri M. Denha**

I Knew I Was a Woman When...

When you were growing up, as a little girl, what was the image you had of what a woman was or should be?

My Mother, Myself

Do all girls eventually become their mothers? A college professor once told the students in my relationships class that if a guy wants to know what his wife will be like in 20 to 30 years, he should just look at her mother.

I don't know if that is true in all cases. I have six sisters and we all resemble our father's family. But, the images resembling what I thought a woman should be definitely came from my mother. My first images of womanhood actually came from my entire family—my mother, grandmothers, aunts, older sisters and cousins.

Although I believe I am created more from the image of my father than my mother, my ideas of who a woman was or should be came from my earliest depictions of my own mother. I recall a photograph of my mother at the age of 14. She is wearing a Middle Eastern robe covering an ankle-length floral dress.

In the photo, my mother is standing against a wall. Her head is covered with a turban-like headdress. The outer layer garment is a waist-length, long-sleeved black coat with white trim that buckles below her chest. Underneath the coat is a gray and white striped robe covering a blue, green and white floral dress. Her hands are folded together just underneath her stomach. Her cheeks are a shimmered-rose color but she wears a frown on her face.

Looking at that photo, I see the face of a woman who knows that somewhere else in the world, there is a better life to live. I see this childlike woman wearing a costume she is uncomfortable to be in. She is a person living the life she was told to live and not the one she chose.

In my mind, as a little girl, I was happy to be the child and not this person. I don't look forward to the life I see the woman in this picture living—the life of an adult. It was a life of repression, self-doubt and pain, all predetermined by a culture. I wanted to pave my own path and this woman was traveling a road that someone else laid out for her. She took the turns on the roadmap without one thought about where she was headed. She just followed the directions.

I wanted to create my own map, not follow someone else's. Thank God this woman eventually got off the road she was on. One year after this picture was taken, she met the man who would hold her hand and take her to the world she knew would offer her freedom and opportunities. And my image of what a woman was or should be continued to unravel as my body began to develop and my mind was nourished.

My grandmother has had Alzheimer's disease for several years and my early recollections of her are many of the same things: giving us candy, gardening, making us breakfast, walking to church, cleaning her house—a place that resembled a church.

My grandmother walked to church every day to attend mass. She had pictures and statues of Jesus and Mary all over the house. She spoke broken English and very little of that. She made the worst Rice Krispie treats in the world, but my sisters and I never missed a chance to go to her house to eat them.

The summer my family moved back to Michigan from California, I stayed with my grandmother in Detroit. She was taking English classes and the workbook she was studying was much like the one I just had in the second grade. She had me quiz her. She laughed like one of my school friends at the

95

funny sounding words. She taught me some Aramaic and I taught her some English, but most of all we taught each other that no matter how many generations and miles apart you are there is a bond between women.

My grandmother, like my mother, grew up in Northern Iraq in a town called Alquosh. They were churchgoing people who lived in the mountains, and my grandmother's knowledge of life was limited to raising children and praying to God. Her 900-square-foot home in Detroit was a castle to her and her tomato plants and cucumber seeds were the garden she nurtured.

As a little girl, you don't appreciate your grandparents like you do as an adult. I wish today I could talk to her and ask her questions. Unfortunately, she no longer knows who I am. Whenever I saw my grandmother, I saw a woman who was clean and who took pride in her home and in her family.

My mother and grandmother were not just generations apart from me. They were worlds apart as immigrants to this country. I couldn't relate to their portrayal of being a woman in the United States. While my mother was raising two children, her American peers were going to prom and preparing for college. They dated and she had an arranged marriage. They were part of the women's movement and marched for equal rights and burned their bras, while my mother cooked, cleaned and changed diapers.

As I grew older, my mother started to truly emigrate. She took yoga, jogged every day, and even graduated high school shortly before I did. She knew that this country gave her a gift and she wanted to enjoy it.

When I think of my mother, I think of a woman who, if born in a different time and in a different country, would have done great things, but she did the best with what she was given. Her greatest achievement was being a mom and one that kept her seven daughters in line.

~

Image I Had of What a Woman Was or Should Be...

I had different images at different times. My mom, of course, had to be my most obvious example because she was with me always. She was a stay-at-home mom who was always home when she needed to be, but also took us kids wherever and whenever we had to go somewhere. I thought ALL moms did this, but I soon found out that was not the case.

She always volunteered at school or camp, or at my theater and music group; she went to all the boys' sporting events and our golf tournaments and school events. However, I also noticed that other women in the neighborhood did different things. Some worked, some had no children but were always home when their husbands came home, and one lady even owned a restaurant with her husband and his brother. I was very little then, but I thought they were so mysterious because they had their own business.

Imagine that!

*In school, I was always enamored with my teachers. They were Miss or Mrs., but I could never imagine them in a private life outside of school. I would only visualize them as teachers and nothing at all like my mom. So, I suppose I've never had only one image of what a woman should be. Having been exposed to so many different kinds of women in my life allowed me to see how multifaceted women could be. —**Janina Jacobs***

~

Image I Had of What a Woman Was or Should Be...

*That was so long ago, but I think I thought a woman should be like my mother—protective, gentle, caring, taking care of everyone, with an air of vulnerability. —**Lois Teicher***

~

Image I Had of What a Woman Was or Should Be…

I grew up in an ethnically diverse middle-class neighborhood. All of the parents were immigrants, all of my friends "first generation something." Most of us spoke a language other than English at home. When your parents overcome obstacles to seek out a life in a foreign country, you better believe you feel an awesome responsibility to make something of yourself.

The old neighborhood produced a couple of doctors, engineers, nurses, teachers, and a broadcaster…that's me, and most of the other kids in the neighborhood would prefer not to mention this obvious scholarly failure. My own father made it to this country with the proverbial "dollar in his pocket." He ran a successful construction business and sent each of his three children to college. I am the only woman in my family ever to graduate from college. I know I won't be the last.

So, my image of a woman when I was growing up was one of service.

All of the mothers in my neighborhood were stay-at-home, full-time, gingham checked apron, "don't make me come back there" moms. Their sole jobs were to serve their families and each did so in stellar style, long before Martha Stewart provided specific tips on the best way to organize a fresh smelling linen closet.

My earliest memories were of all of the dads in the neighborhood going off to work each morning, and the moms staying home. Not one single family did it another way. The only women who worked outside the home were teachers, nuns and the women who worked at the bank or grocery stores.

Somehow I knew this would not be the life for me. There were no role models for a "working woman," although all of the women I knew worked really hard…they just didn't get paid for it. I take that back—I can hear a couple of them admonishing me at this very moment saying sloppy kisses from the kids and a husband who loves you was payment enough.

The women's movement came along, I believe, just for me. I'm often teased in the newsroom that I can type without looking at the keys, "professional secretary style." I often have to explain that the reason for this is that when I arrived in high school I told my advisor that I planned to go to college. She sat back in her chair, folded her hands, sighed and told me girls really didn't go to college, except the very-very smart ones (read: girls who have careers don't get husbands). She suggested "business classes" would be best for my future. Thankfully, she left at the end of my freshman year and was replaced with a man who said, "If you want to go to college, what are you waiting for? Get busy!"

On to college I went, and, yes, I married young, had a baby young and had to put going full throttle toward a career on hold while I tended to my kids. But, ultimately, I did accomplish what I wanted with my career.

I also made sure that my husband and I raised our daughter with the assumption of endless possibility, and with the understanding that the only limit in life is oneself. —**Marie Osborne**

~

Image I Had of What a Woman Was or Should Be...

My mother was very happy being a housewife. I didn't necessarily want that role. I don't know if I really had role models and said, "Oh yes—this is what I want to be." I think I kind of grew up with the sense of what I didn't want. I knew that being a traditional housewife alone wasn't going to make me complete as a person. Instead of being just a woman, I wanted to be a complete person and experience everything.

What I really also came to believe is that people can become super women. I believe we have to make choices. I don't think we can do everything at the same time. I don't think we can be 25 and to be climbing the corporate ladder to be a Fortune 500

president and CEO, and be a great wife and a great mother. I don't think anybody can do that. That has to do with being a person. I grew up watching Mary Tyler Moore. She was going to work. She was a single person. I saw that women's roles were changing and the show helped defined that.

My mother always worked part time, but she was always very much in charge of the household. I had an aunt who worked a lot but it wasn't really a career. I observed other people and a lot of it was realizing what I couldn't do. I watched women trying to do it all. Men never really tried to do it all. Men never said, "Hey, I am trying to be Superman." Women did. I don't think that worked. —**Pam Johnson**

~

Image I Had of What a Woman Was or Should Be...
Growing up, I felt that a woman was a person who got married, stayed home and cared for her children. A real woman stayed home with her children rather than having a stranger care for them. I saw the role of a woman being a traditional one. —**Anna Elizabeth**

~

Image I Had of What a Woman Was or Should Be...
While I was growing up, the image of a woman that I had, was that of my mother and my teachers, all very strong and feminine. —**Mercedes Sosa**

~

Image I Had of What a Woman Was or Should Be...
My mother was a woman of great unhappiness. Her ultimate pleasures were shopping for clothes and things of little depth. She was not a natural nurturer, and directed mothering was

not her foremost concern. Ill-equipped, she performed all those appropriate scheduled and expected duties of a non-working mother in the late 50s.

Her generosity was over the edge, as compensation for a lack of emotional substance. I was clothed to perfection, and well cared for in ways that were perfunctory. She lived in a middle-class world that was foreign to her, and made those around her feel foreign and emotionally at bay at all times.

Was she a role model? Hardly.

My devoted and intellectually gifted father was determined to develop his daughter into a complete and independent woman—one who was self-sufficient, emotionally connected, self-confident, and able to stand on her own; a woman that would not need a man to be successful in business or in life. He instilled the desire for constant and continual learning, a passion for life and love, and the concept of "happiness" being purely a choice. He made a mental collage for me of what a woman should and could be, dissimilar from his own committed choice. —**Ruth Mossok Johnson**

~

Image I Had of What a Woman Was or Should Be...

For me, my mother was and still is the perfect image of a woman. I remember how much my mother admired Jacqueline Onassis when I was a child. I was grown up with kids of my own before I understood why. For my mother, the perfect woman was full of grace under fire. She kept her woes to herself and made sure that the people around her were cared for and content.

She sacrificed whatever was necessary for the sake of her children. She made her husband proud. Just like Jackie O.

My mother did everything well, and I admired her for the cocoon of safety, love and support she created for me as a child. But when I became a teenager, my budding feminism

also awakened something in her. We started growing up together as women outside of our men and our children. She began to explore her own potential in middle age—from studying to become a social worker to running her own business. And she did it all with the grace of a First Lady.
—**Desiree Cooper**

~

Image I Had of What a Woman Was or Should Be…

On most days I love my life and on the days when it "stinks" I suck it up, move on and thank God for an opportunity for a breakthrough!

It's kind of funny…now that I look back, I see my views on who or what a woman was totally influenced my immediate culture. My mom was divorced and so were all of her closest friends. She and her friends supported each other, laughed together, (secretly) cried together, complained about their ex-husbands together, etc.

The one thing that stands out most about my mom and her friends (Aunt Lillie & Aunt Blanche) was that they were very smart and savvy. They knew how to get things handled no matter what the situation. I would listen to my mother on the phone handling business. She was always so smart sounding and quick thinking. My mother favored getting things done on the phone because the business people couldn't tell if she was black or white. So as an intelligent "white" woman she got a lot further.

All the women in my family were strong, though. My great-grandmother and her sister came from Louisiana with nothing and did as well as they were allowed to do in the 20s and 30s. But most of all, they were so proud.

If they cried at all, I never saw it. If any woman in my family cried, I didn't see it. I mean, they never cried unless someone died. And even if someone died, there was still work to be done

102

so you can't cry long. They stood like big old oak trees unwavering in their trust in the Lord. She was strong, smart and observant. A woman is always thinking three steps ahead. She would never let them (anybody) see her sweat! —**Charilyn Hackney Goolsby**

~

Image I Had of What a Woman Was or Should Be...

My image of what a woman was existed as a polarity. Being a product of the 60s and 70s, I was on the cusp of the women's movement and was exposed to two very different perspectives on womanhood. My mother represented the ways of a housewife, while the media exposed me to images of women who were out in the world.

I especially took a liking to Mary Richards in The Mary Tyler Moore Show, *the Enjoli woman who could bring home the bacon and fry it up in the pan, and Charlie's Angels who exuded personal confidence and feminine power. These were the images I gravitated toward as I formulated my dreams about being an adult woman some day. I decided I would select this option over the alternative of being a housewife who labored over the domestic responsibilities of running a home.*
—**Laurie Mastrogianis**

~

Image I Had of What a Woman Was or Should Be...

We were very poor and I lived with six aunts and uncles, Grandmother and Grandfather, Mother, Father and two sisters all in one house. I got examples and mentors from all of them. My six aunts, who were single, and my grandmother worked.

They taught me how to iron and how to cook. I remember going down on Monday nights to learn how to iron, and when I advanced from a handkerchief to a pillowslip I thought that

was the greatest thing in the whole world. Then I was able to do blouses.

*These are the things I was taught by family. I was always taught I would go to work. I was always told that I was terrific and that I was lucky. I believed those things all my growing-up years. My whole family was fat and I didn't know that I was different until I went to school. When you live with family that is terrific there is always someone to go to and curl up with and get a hug and get a kiss. And the fact that my aunts worked made them mentors for me. —**Florine Mark***

~

Image I Had of What a Woman Was or Should Be…

I grew up in a traditional Chaldean family. My mother was a homemaker and my father worked to support the family. Growing up, I watched my mother cook, clean and take care of her children and her husband. So it's no surprise that in my younger years I thought a woman's only destiny was to be a wife and a mother. At the time, these were considered submissive roles.

As I got older, I started to understand that my mother, as a wife and a mother, was supporting the family just as much as my father was, but in different ways. She might not have been contributing financially to the family, but she was our teacher, our emotional support, our friend and our protector on a daily basis.

*Every day, she told me I could be anything I wanted to be—a doctor, lawyer, teacher, construction worker or homemaker. She encouraged me in school and motivated me to excel. Because of my mother's life lessons, my image of what a woman should be became someone who was strong and capable of taking care of herself and her family. —**Joan Abbo Collins***

~

Image I Had of What a Woman Was or Should Be...

When I was about 14 in the mid-50s, I had an aunt whom I admired and wanted to be like. She had a husband, a son, a good job as a secretary (rare for a black person during those times), owned her own home, had a nice car and dressed really sharp. I thought she was the epitome of my idea of a woman.

I grew up to have a husband, one son, a good job as a secretary (to Detroit Mayor Coleman Young for 16 years), a nice car, owned my home and dressed pretty nice. She divorced and was a single parent for years before remarrying. I divorced, was a single parent for 10 years and then remarried my ex-husband and have been remarried for 24 years.
—Bernice Cater

~

Image I had of What a Woman Was or Should Be...

My mother was a stay-at-home mom and she was always there for us—sending us off to school, always having meals on the table and she was at the door waiting for us when we would come home. That is what a woman meant to me when I was a little girl. —Jennifer Thomas Abbo

Holy Mary Mother of God

I spent several years of my life in plaid. I wore plaid blue and white jumpers, plaid blue and white skirts, and plaid red and white skirts, until junior year in high school when I wore a solid gray skirt with a button-down shirt every school day for two years.

You guessed it—I am a product of Catholic School.

I grew up in a strict religious family and I went to Catholic school for 13 years—four years at an all-girl high school. Even now, after my father has passed, I can hear him scolding me for not going to church. The guilt is not from the fact it's considered a sin not to attend mass every Sunday, but from the image of my father up in Heaven looking down at me with disappointment.

In fact, I am sitting in my office on a Sunday afternoon writing this chapter and I haven't gone to church yet. I contemplated continuing my writing and not going to church at all, even though I can still make the 5 o'clock mass at St. Hugo of the Hills. But the second that thought entered my mind, I heard my father's voice say: "GO TO CHURCH!"

My religious upbringing and influences—including the nuns at Catholic school and the shrine to Mary my parents created in our home—have greatly influenced me as a woman.

It was purity versus what was perceived as evil in the world. Finding a balance between emulating the Virgin Mary and

growing up in a world with MTV and Madonna singing "Like a Virgin" can really confuse a girl.

I didn't understand how a woman who could become a nun and live a life of celibacy, but I couldn't see myself posing nude for *Playboy*, either. It was the guilt of a Catholic school upbringing that truly mixed up my images of what a woman was supposed to be. After putting the pieces together, the image of a woman resembled a Picasso painting—you can't really figure out who she is.

I am still a Catholic, but now I just put things in perspective. Instead of believing what the nuns told me in grade-school—I would go to Hell for every impure thought—I can interpret the Bible and religion through self-education and research.

I am a regular listener to Detroit radio personality Teresa Tomeo. She often imitates her mother for her Catholic listeners. Using a Brooklyn drawl, she says that when she first started dating, her mother would tell her "The Holy Mother is watching you." That's Catholic guilt in full force!

Mother Mary wasn't the only woman in the Bible who had an impact on the world. Mary Magdalene was a woman that represented someone who could make mistakes and move on. It was Mary Magdalene who taught me that no one was perfect.

When I think of a woman who has triumphed, who lived by her terms and who lived in the world and not of the world, I think of Mother Teresa.

I know it is no longer politically correct to mention God or religion, let alone Catholicism, but this book is about being who you are, politically correct or not.

I am not letting society define me as woman. I am letting the truth do that, and the truth is: I was molded by the Catholic faith and by the purity of Mother Teresa. She lived life as a servant and her words are quoted by some of today's greatest philosophers.

Mother Teresa defined strength, love, honesty and truth in her work and by her mere existence.

She defined being a woman, a mother, and a saint.

A saint, years before our time, is one that many girls in the Catholic faith today can relate to—St. Therese. She is a role model for many young girls, even centuries later. Recently there was movie made about her. She was known as an ordinary girl with an extraordinary soul. St. Therese was born in 1873 in France at a time when Europe was on the verge of tremendous change. The Industrial Revolution, which roared through England during the 18th and 19th centuries, initiated the age of technology. The art Impressionist movement centered in Paris and broke with the classical and romantic styles in painting and music. The French Revolution and Enlightenment of the 18th century challenged the tradition of the age.

But the reason so many young Catholic girls try to emulate her, more than a century later is that she was a normal young girl; in fact, a mischievous one who was quite spoiled.

Her mother died when she was 4 years old and to compensate for her loss, her father, a watchmaker, gave her whatever she wanted. Four of her eight siblings had become nuns while Therese was far from being a saint at the time. She was known to throw temper tantrums, stomping her feet if she didn't get her way.

She was known as her father's "little queen," did whatever Louis Martin could to keep his little girl happy, even though he was protective of his daughters. He didn't allow them to read the newspapers, fearful that it would make them too worldly.

History shows that St. Therese became ill, physically and emotionally. She was healed when a statue of the Virgin Mary smiled at her. She experienced a profound conversion on Christmas Eve 1886, at the age of 13, and later became a Carmelite nun.

Not many of us will follow the path of St. Therese, but sometimes in life we need extraordinary stories from ordinary women to move us, to motivate us and inspire us to better our own lives.

As a product of the Catholic faith, I look to women in the Bible, in history and in my own life to motive me. I encourage others to look at their own culture, religious books and the women in their stories. Whatever your faith, you're sure to find stories of women who have gone beyond the call of duty, who have transformed into profound human beings.

St. Therese was a mischievous little girl who grew into a woman with monuments, statues and prayers named after her. She was a poet who believed and taught that "everything is grace." Despite her desire for drama, Therese developed a simple spirituality based on a childlike trust in God. The spirituality of her "little way" was not about extraordinary things, but rather, about doing simple things in life well and with monumental love. At the direction of her spiritual director, and against her wishes, she dictated her famed autobiography *Story of a Soul*. Many miracles are attributed to her. She was declared a doctor of the Church in 1997 by Pope John Paul II.

~

Image I Had of What a Woman Was or Should Be...

Looking back now, I realize that I was trying to live up to what the world thought a real woman was supposed to be. Growing up in the 70s, it was all about women getting ahead. Every commercial, magazine article and TV program talked about women's liberation. We were told that true freedom and liberation meant not needing a man.

If you found one, great. But it was still all about putting yourself and your needs first. And you were brainwashed into thinking that if you gave up your career to stay home and raise a family, you were being used or stifled. As a result, I put everything into my career, and my identity as a woman was in what I did for a living, not who I was inside. This approach left me empty, bitter, unhappy and, frankly, burned out. It also almost cost me my marriage and, even more importantly, my

109

soul. And the idea that a career is everything is a big fat lie because a position or a title, no matter how prominent, can be taken away in a second. I know because it happened to me more than once.

It wasn't until I really started questioning and searching and eventually deepening my relationship with God that I realized what being a woman really meant. It means accepting the unique and beautiful things about the way God made women. It means not having to be like a man or compete with men for everything, and it also means having the ability to love others as much as you love yourself. I like to use the word JOY as an acronym: Jesus first. Others second. Yourself last. The more I give, the happier and more at peace I am.

Now that I focus on God and how He can use me to make a difference, things seem to fall into place and my work as a speaker, writer and Catholic talk show host gives me so much more satisfaction. My role as a wife and partner has also taken on a much deeper meaning because I can truly give myself to my husband in a covenant relationship, unconditionally.

I was in the rough and tough broadcast news business for 20 years in Detroit. And while I gained some great experience, there was always something missing. I had to prove myself over and over again, no matter how many exclusive stories I broke. They always wanted more and pushed for more. And they didn't take kindly to people, especially women, who had family commitments outside of work. —Teresa Tomeo

How Wonderful Life Would Be
If Only I Were Wonder Woman

Lynda Carter wore the greatest costume ever. Perhaps I fell in love with it so quickly because I was born on Flag Day and somehow I had this inborn patriotism.

I don't know.

But that costume and the woman inside the suit portrayed power and grace. I wanted to be in control like she was. It was the first image outside my family and culture of what I thought a woman was or should be—Lynda Cater as Wonder Woman.

I was mesmerized at the turn of every episode as she fought evil and won. She wore these gold wristbands that she could bounce bullets off of and she protected herself from any harm that would come her way. I wanted this type of protection. I wanted to do this for myself.

My parents gave me a Wonder Woman bathing suit for my first holy communion. I wore the red, white and blue suit every day that summer. We lived in California and had an in-ground pool. The neighborhood kids, my sisters and I would reenact the *Wonder Woman* scenes. I, of course, was Lynda Carter's "Mini Me."

There are many characters Hollywood has brought to us women that we have tried to emulate—some good, others destructive. I am grateful that I never tried to identify with Twiggy. I was a child whose body resembled that of a Cabbage

Patch doll and growing up to look like Lynda Carter in the Wonder Woman costume was already a stretch.

How we identify with our womanhood does reflect our body images, despite the fact that in the 21st century it is no longer politically correct to even talk about wanting to be sexy and pretty.

I resented this throughout my 20s. I hated the fact that men tended to be visual and many of those I met were turned off because I was a tad overweight instead of being turned on by my mind. I wanted to challenge their intellect and I wanted to be wanted for me. I even boycotted fashion magazines; and read current events, medical journals and magazines for writers instead. I was an intellect. I was a reporter who interviewed important people. I wanted to prove to the world that I could be sloppy and overweight and people would respect me. Was I right?

NO WAY!

I was resentful that people wanted me to be thin and put me on some pedestal that seemed so out of my reach. I didn't realize at the time that I didn't have to accept society's image. I just had to find a way to be comfortable with me.

It took me a decade to realize that my body image is part of who I am. It's not about being a size 6, standing 5'8" and weighing 120 pounds. It's about taking care of myself, working with what God gave me and being confident in that image.

While I turned away from makeup and designer clothes in college, I secretly envied the Grace Kellys, Marilyn Monroes and Audrey Hepburns of the world. I wanted to be pretty. I wanted to be graceful. I wanted to be sexy. I didn't know how to do that.

Growing up as a little girl, part of me liked the frilly dresses and tea parties even though I played soccer and hung out with boys. My images of what a woman was or should be evolved as my caterpillar of a body emerged into a butterfly.

Then there was Barbie. I had Barbie dolls but I didn't really

know what to do with them. I was more of a child who liked to play board games and hopscotch. This Barbie was a mystery to me. What did she do? She represented a body image and that was all, yet I somehow saw her as this woman I was supposed to be, a woman with a man, a camper and a pool.

Okay, then what? I read once that if Barbie were a real woman, since her body is not proportioned, she would have to walk on all fours. What a reality check!

All these images I had were part of what the media and society told us we were supposed to be. Some of these images did mold us in positive ways, but many women are still fighting with reality and the fantasy created by some advertising representative or movie house executive.

When I watched *Wonder Woman*, I saw an attractive, confident and powerful woman, and I thought that is what a woman was supposed to be.

~

Image I Had of What a Woman Was or Should Be...

Being a childhood actress, you had some power growing up. I felt like I had a power at a young age, because I was always treated like a little princess. I worked hard, but I felt the power that a woman had. I really didn't know what it was, but I knew it was there. I got to play a lot of different characters. I also saw the women I worked with—the stars—like Loretta Young and Donna Reed—people in the public eye. I saw how they handled themselves and I was immensely affected and impressed by them, Maureen O'Hara, especially. She had a lot of power. By power, I mean she can really make emotions come from other people. She could really give of herself. She stood firm for her beliefs. That affected me when I was growing up. I always thought that being a woman was a fortunate thing. I loved being feminine, because I felt intuitive and sensitive. I

liked being able to cry and feel my emotions when I was growing up. —**Karolyn Grimes.**

~

Image I Had of What a Woman Was or Should Be...

A woman was a daring, revolutionary woman against any oppressor, from a sexually harassing father, to an unworthy husband, to a mean boss, to a foreign army, simultaneously she was a devoted mother. Following the events of her time and the development of the socio-eco-political situation and taking a responsible position as a citizen. —**Ioanna Karatzaferi**

~

Image I Had of What a Woman Was or Should Be...

Some of my earliest impressions of what I thought a woman should be came from watching Marlo Thomas's TV show That Girl. *I was pretty young at the time, but I remember thinking, even as a kid, that the way she was living her life appealed to me. She was an independent woman (something I didn't have many examples of) and, as a young girl, I thought it was great...I still think it's great.* —**Ann Delisi**

~

Image I Had of What a Woman Was or Should Be...

I always enjoyed a good challenge. When I was young, my challenge was for freedom, which I didn't get in the Middle East. A woman's option is not respected. It was why I chose to become a geologist, it gave me some freedom. We were supposed to do work, but in our country, women didn't travel without a man from her family. Women were oppressed, second class, if that.

My study group of five women challenged the university's

law in our department. We suffered from some of the staff and teachers who did not want us at the university. But, we prevailed and the doors remain open for women today.

In my family, I was the first young woman to travel by herself. I went to study in Europe. When I got my Ph.D., I felt I won a victory. I was furthered challenged when I fought with men in North Iraq; I joined the Kurdish army in 1982, called Peshmerga, which means those who fear no death. I was fighting for the rights of all women in the Middle East.
—**Katrin Michael**

~

Image I Had of What a Woman Was or Should Be...

My images came from the movies. Joan Crawford, Betty Davis, Barbara Stanwick and the like, who wore beautiful clothes, long, sequined gowns, high-heeled shoes and smoked cigarettes that never went out. What I actually saw at home was women cooking, cleaning their houses and those of other folks having too many babies and never getting enough rest. —**Jacqueline Shellman**

~

Image I Had of What a Woman Was or Should Be...

I didn't have any image of womanhood because my grandfather told me from the time I was three that there wasn't anything in this world I couldn't do, and I believed him. I would go to sporting events with my grandfather. I had my own season ticket at Fenway Park when I was three years old. I was going to be a big Broadway star. He even bought me a piano.

My mother was educated. My aunts were all educated and worked. I didn't know that I wasn't supposed to do this until I was a grown-up and found out that people didn't want women in journalism or, particularly, in sports. I was 40 when I found

115

that out. I never had an idea of what a woman should or shouldn't be. I just believed what my grandfather told me.
—Suzyn Waldman

~

Image I Had of What a Woman Was or Should Be...

I grew up in Iraq, under the repressive rule of Saddam Hussein's Ba'ath regime. It was awful, and I felt the pressure and lack of freedom very clearly as a little girl.

One of my most distinct memories is from third grade, around the time I began wearing hijab. I was sitting in a garden, on a swing, when I looked up in the tree above me and saw a bird. Suddenly I desperately wanted to be that bird, to be able to fly away from the enclosed life I had to live in Basra. Without realizing it, I was forming my image of what a woman should be. My ideal woman was a bird. A woman should be free, should be able to rise above the world around her and try to make it better. The reality around me was clear: that women—and almost all men, too—did not have any ability to change their society. So I also understood that being a woman involved suffering. —Zainab Al-Suwaij

~

Image I Had of What a Woman Was or Should Be...

I grew up watching Cher on television. I don't know if it was a good thing or a bad thing, but I saw false eyelashes, sexy clothing, glitter and sequins and for a long time I thought that was what a woman should be like. Once I became a teenager, I realized that probably wasn't the smartest way to go and I think I became the woman I am by the various people in my life—my mother, my grandmother and the neighbors. My mother always had a list of rules to live by that she often shared aloud.

1. *Buy lemonade from kids on the curb who sell it.*
2. *Always tip street musicians*
3. *When the circus comes to town—go.*
4. *If you can vote on something always vote.*

—**Rachel Nevada**

Another "SitChat" topic: Ask Yourself...

What women do you want to emulate and why?
Who did you admire when you were growing up?
What role models do you want your daughters to have?

Looking at Myself
Through Someone Else's Eyes

I had so many different images and role models of women as I was growing up. I was thinking back to all those women in my life when I realized why I had such a difficult time feeling like an adult woman, even though my body had formed into one and society considered me one because of my age.

Sometimes, we end up learning more about ourselves when looking at ourselves through someone else's eyes. Our perception of ourselves may differ from the perception other people have of us.

We observe role models in our lives but, in turn, they are observing us—our behaviors. We can learn from what they see.

Some of the female influences in my life dominated other female figures. Regardless, both the subtle and the strong made an impact on my life and contributed to the woman I am today.

There was not one woman in my life or on television when I was growing up whom I identified with completely. Nor, is there one today. There have been and continue to be women I admire, like Mother Teresa, and Oprah Winfrey, as well as non-public figures—women in my everyday life.

Today, I appreciate qualities in my mother and my sisters and often look to each of them for guidance, comfort and encouragement. We are all born with gifts and talents that mold our characters and contribute to the careers we pursue and lives we live. Although my sisters and I grew up in the same

household and were born to the same parents, we are individually identifiable by our personalities and reactions to even the same situation.

Our individualities are often defined by our reactions to various events such as death, surprises, marriages and births. We may all have been reared with the same morals and values regarding life, but our inborn personalities often dominate our personas.

Regardless of our role models, much of who we are, I believe, is already within us. In addition, the same person can influence us differently. I learned this when my father died. Each of us reacted differently to the same loss. I understood why when I realized that my father meant different things to each of us, including my mother. So the absence of him was experienced on different levels for each daughter and his wife.

He was instrumental in influencing my transition into womanhood. When I think of my father, I often think of the song by Celin Dion, "Because You Loved Me." In fact, it would have been the song to dance with him at my wedding, if he were still alive. I believe I am who I am only because my father loved me.

We can admire a woman with a fabulous physique, one with tremendous confidence, one with a mother's instincts, or another with an exciting career, and we can try to mimic their lives, but a woman is defined by knowing herself.

My father helped me figure that out.

He was "my eyes when I could not see." He saw me before I did. He guided and nurtured me. He knew my faults, my weaknesses and my strengths and he helped me see them for myself.

The lyrics to the song are true to life for me. He stood by me. He brought me joy and made so many of my childhood dreams come true. He was everything to me. As a little girl, I believed that my father was almost omnipotent and had a direct link to God. If he wanted, he could make the rain stop.

As women, our role models do not always have to be other women we want to be, or women whom we grew up with or were affected by, but they are those people who unconditionally love us for who we are already.

~

Image I Had of What a Woman Was or Should Be...
*A cook, housekeeper, mother working outside the home, gardener, peacemaker, teacher. —**Patti Alef***

~

Image I Had of What a Woman Was or Should Be...
*While growing up, I had an image of women in general as being competitive and not easily trusted. It always bothered me how a female could be a friend, but not use common sense when it came to friendships and not defying them. Women always reacted far too much on the emotional side. I had always noticed that men did not do this, so maybe that is why I had more male friends than female friends (only up until I married). —**Lisa Patrico***

~

Image I Had of What a Woman Was or Should Be...
*Growing up, I thought of women as people to be protected and loved and respected by men. I didn't see any disconnect between that and my ambitious goal of becoming a Nobel prize-winning scientist. —**Dr. Laura Shlessinger***

~

Image I Had of What a Woman Was or Should Be...
Like many young girls in the 1950s, the women who were a

I KNEW I WAS A WOMAN WHEN...

part of my life, as well as the images portrayed by the media, molded my early image of what women were or should be. Those role models ranged from a grandmother, who was trained as a schoolteacher, to my mother, who was, and is to this day, is a homemaker.

My early role models embodied traditional family values but were strong-willed. While most of the women I was surrounded by in my life were not employed outside the home, they were, nevertheless, hard working and smart. Those qualities are qualities that I have applied to my life as a working woman in the 21st century. —**Candice Miller**

~

Image I Had of What a Woman Was or Should Be...

I thought being a woman meant being a wife and mother. That was the role that I saw played out in the home. As an adult, I struggled when I neared my 30s because I thought that I wasn't fulfilling the purpose for which woman were intended: to be a wife and have kids. I know now that you don't have to have those experiences or make that type of contribution to the world to be a woman. I also understand that no man defines my womanhood—only God. —**Faith Green**

~

Image I Had of What a Woman Was or Should Be...

I think if someone had me draw a woman when I was a girl (8, 9, 10ish), she would have been a picture-book icon. She would have worn a dress, gloves and a prim hat. My mom was nothing like that. One of my favorite memories is when she came out and jumped rope with my girlfriends and me. My mom was 42 and pregnant with her 10th child at the time. I was 12. —**Peg McNichol**

121

~

Image I Had of What a Woman Was or Should Be...

As a young child, my first image of a woman came from my great-aunt Alya. Born, raised and educated in Lebanon, she abandoned everything she had ever worked hard to achieve on her own merit—even sacrificing every woman's wish to have her own family—to raise and care for her brothers, sisters, nieces and nephews as if they were her own children, until they day she died. She taught me through her actions that there is no greater love than for one's God and family. **—Nicole Rashid**

~

Imagine I Had of What a Woman Was or Should Be...

The toughest thing for me was that you didn't see women playing sports. You heard of the golfers, maybe some of the tennis players. I tell people my heroes are Mohammed Ali, Shred and Walt Frasier who played for the Nicks. The first impression of women doing something dynamic is Billie Jean King beating Bobbie Riggs. As I tell Billie today, I had no clue what she was doing for me back then. I understand what she has done for me today better than I did back then. It was disappointing that I didn't have those female role models. **—Nancy Lieberman**

~

Image I Had of What a Woman Was or Should Be...

Though I am now 41 and should have pondered this before, answering this question was a revelation to me.

I realized that there were no feminine role models for me. My father had no sisters. My mom's best friend was a cranky old maid. There are probably 50 women on my mother's side

122

of the family, and not one is feminine. They are big-boned, asexual women, who speak gruffly and would wear a dress if they had to, but it would hide their figure, not highlight it. They are tough, farm-bred, admiring hard work, battles, and tomboys. Such is the young girl I became, for one molds oneself in the praise one receives. Tears were not welcome—not for the suffering, not for the dead. It's a shame, really, for I have spent much of my adult life learning that it's okay to be feminine and have feelings. It's okay to cry about losing my father when I was eleven.

It's okay to be angry with the boyfriend who measured my nose because it's not small. It's okay to feel sad when a friend's offhanded remark stings your heart. And it's okay to talk about those things, too! It's also okay to look pretty. I never heard "Maureen" and "pretty" in the same sentence until I was in college.

My mom would always say (and still does), "You look nice"—an androgynous, safe compliment. I've learned to define womanhood on my own terms, and move away from my mother's comfort zone. She doesn't understand it, but I can't help that. I'm not a farm girl—I've lived in Paris! I'm creative and sexy. It works for me, and that's all that matters.
—Maureen Electa Monte

Sometimes I look in the mirror and staring back me is the little girl I was and the woman I want be.
—**Vanessa Denha**

Growing up, what was the image you had of what a woman was or should be...

How would you define what it means
to be a woman today?

Yes, I Am a Woman NOW!

You have come on this journey with me and made it this far, so my final question to you is: How would you define being a woman today? I asked my interviewees and, here, I share their answers with you. In addition to the definition, I asked each to write a description of herself.

Defining a Woman Today...
Independent, self-sufficient, adventurous, confident in her abilities, physically fit and nurturing. —***Linda Bachrack***

Linda is a recently divorced writer and editor on a quest for self-discovery.

It Was Said...
Somehow we learn who we really are and then live with that decision. —**Eleanor Roosevelt**

Defining a Woman Today...
Women today are striving to find balance between the two polarities: how to love our children and anchor our homes while also expressing our gifts and talents in the world.
I see women today building a bridge between what used to seem like such opposite experiences. I would tell my daughter that the women of today are about embracing their traditional

qualities of nurturance, wisdom and stability, while also cultivating a creative expression of themselves to share with the outside world. Sometimes this entails pursuing a career outside the home and sometimes it entails making a difference in the world from the comforts of one's own home.

The beauty of being a woman today is that we have choices—and, regardless of what we choose, if it's done with self-worth, confidence and personal power, we're living true to what it means to be a woman. No judgments and no regrets. This is the motto of women today. It's the essence of the saying, "Know thyself and to thyself be true." Referring to the famous quote from Shakespeare is "To thine own self be true, and it must follow, as the night the day, thou canst not then be false to any man." **—Laurie Mastrogianis**

Laurie has her Ph.D. and is a university professor, wellness counselor, author, devoted mother, and a woman committed to walking the path of personal wellness.

Did You Know...
 One of the original feminists in the United States worked for the Temperance Society and encouraged the abolition of slavery. Susan B. Anthony was born February 1, 1820, and helped increase the civil and political rights of black males after the Civil War. She also campaigned vigorously for the right of women to vote but died in 1906 before the passage of the 19th Amendment.

Defining a Woman Today...
 *I would say there are so many options for women these days and only they can know what will truly make their lives fulfilling. But whether they choose to be a lawyer, a homemaker or any of the hundreds of thousands of other occupations available to them, they need to understand there is strength in whatever honorable path they forge. —**Katherine Leslie***

127

Since 1993, Katherine Leslie has been a radio news anchor in Detroit, where she lives with her husband and two "whippets."

It Was Said...
 I began to have an idea of my life, not as the slow shaping of achievement to fit my preconceived purposes, but as the gradual discovery and growth of a purpose, which I did not know. —**Joanna Field**

Defining a Woman Today...
 There are so many different types of women and I wouldn't feel comfortable defining the whole gender. The only type of woman I feel I can define is the one I try to be. Being a woman is complicated, in a good way. Independent, but still loves her man. Career-driven, but yearns for children. Smart, but likes to be a ditz. A woman loves to have a good time. And, generally, just wants to have it all. —Karla Longtin

Karla Longtin is an art director for a publishing company. In her words, she is a 30-year-old graphic designer who works her ass off and often crumbles under pressure. She's currently in a relationship with a wonderful man and is looking forward to the future.

It Was Said...
 I want to be able to live without a crowded calendar. I want to be able to read a book without feeling guilty, or go to a concert when I like. —**Golda Meir**

Defining a Woman Today...
 I tell girls how important being a female is today. We are productive members of the family and work team. We bring diverse strengths and skills to balance out our male partners. I encourage all women to take care of their own needs. This may sound so selfish to some women because they buy into the idea that they must take care of everyone and they get lost in

the shuffle. The world needs women who know they can and do make a difference. —*Joyce Weiss*

Joyce Weiss, The Corporate Energizer® is a professional speaker and author. She helps take people on the ride of their lives by reenergizing their passion for work. Joyce works with people who want to perform miracles for their customers.

It Was Said...
Once you get rid of the idea that you must please other people before you please yourself, and you begin to follow your own instincts—only then can you be successful. You become more satisfied, and when you are, other people tend to be satisfied by what you do. —**Raquel Welch**

Defining a Woman Today...
I think a woman today should be someone who has identified herself as a person. Women today understand their unique qualities and contributions they have to make in the world around them. There are more opportunities and role models today than there were in the time that I was exploring that in myself. There is really no convention of what a woman is today. It is wide open. Those of us who have the opportunity should offer our experience and encourage young women to be everything they can be. —*Joann Castle*

Joann was driving down a road on her way to her family's cottage in Canada when she spotted a sailboat priced at $90. Although she never sailed before, she bought it, justifying it as her 50th birthday gift. She took lessons and eventually became the president of the American Sailing Institute in Michigan and has sailed in various parts of the world.

It Was Said...
Yes, it's true: We can't control the wind or the rain or the other vagaries of weather. But we can tack our sails such that we steer the course we desire. —**Unknown**

129

Defining a Woman Today...

Being a woman today means being whoever you want to be and doing whatever you want to do. It means knowing that you have choices as a woman. A woman today can juggle a family and a career successfully. Or, she can decide not to have a career and concentrate only on her family. She can be a single mother, a divorced mother or nobody's mother and nobody's wife. It means knowing that you can do anything you put your mind to. A woman today can build a house with her own hands, climb Mt. Everest, drive a race car to victory, be president of her own company—the possibilities are endless. —**Joan Abbo Collins**

Joan is a dedicated wife, daughter, sister, mother and editor who loves reading, writing, cooking and spending time with her family and adorable dog.

It Was Said...

Manual labor to my father was not only good and decent for its own sake, but as he was given to saying, it straightened out one's thoughts. —**Mary Ellen Chase**

Defining a Woman Today...

I think being a woman today is a struggle for women who want to "have it all"—the career, the money, the kids, the extracurricular activities. I think women today need to simplify their lives more. —**Jennifer Pilarski**

Jennifer is a happy, intelligent, self-confident and creative woman, wife and mother.

It Was Said...

She had believed the land was her enemy, and she struggled against it, but you could not make war against the land any more than you could against the sea. One had to learn to live with it, to belong to it, to fit into its seasons and its ways. —**Louis L'Amour**

Defining a Woman Today...

The definition of a woman has changed over the years and it continues to change in this new millennium. A woman of today is certainly an independent woman. The role of a woman is forever changing; the women in our grandmother's day did not have the opportunities that we have today. Our mothers have slowly made those changes along with us—we are the new society of women. **—Jennifer Thomas Abbo**

Jennifer is a 32-year-old interior designer who is married and expecting her second baby.

It Was Said...

My friends have made the story of my life. In a thousand ways they have turned my limitations into beautiful privileges, and enabled me to walk serene and happy in the shadow cast by my deprivation. —**Helen Keller**

Defining a Woman Today...

For me, the role has evolved into a complexity of transactions that have at their core the effects of migration and biculturalism. Much of the native values persist (competent homemaker, skilled cook/entertainer, fashion conscious, etc.), but the voice moves back and forth between shades of mutism (my native culture) and a firm assertiveness (my naturalized culture). The role of women in my life cannot be underestimated, from my fascinating and complex mother to my many female friends and relatives, who provide benefits that are sustaining. **—Jeanette Godfrey**

Jeanette is a dark-haired, "fifty-ish" West Indian-American, clinical psychologist and psychiatric nurse.

It Was Said...
In a letter written by Lucy Stone to Susan B. Anthony,
"Women are in bondage; their clothes are a great hindrance to their engaging in any business which will make them peculiarly independent, and since the soul of womanhood never can be queenly and noble as long as it must beg bread for its body, is it not better, even at the expense of a vast deal of annoyance, that they whose lives deserve respect and are greater than their garments should give an example by which woman may more easily work out her emancipations?"

Defining a Woman Today...
Being a woman today is a day-to-day challenge. Just when the road ahead looks smooth and dry—oops! Another pothole. And you find the only way through is your Higher Power.
—*Jacqueline Shellman*

Jacqueline says she is a spiritual being directed by her Higher Power. She is also a wife, a mother, a grandmother, a granddaughter, a niece, a coworker and a friend. And she says, "What I do is not important, because I am a survivor."

It Was Said...
All we are asked to bear we can bear. That is a law of the spiritual life. The only hindrance to the working of this law, as of all benign laws, is fear. —**Elizabeth Goudge**

Defining a Woman Today...
As a woman today, anything goes. You can make or break your own future and set your own limits. I get very irritated with women who say, "My boss won't let me..." or "My husband won't allow me...." Get some gumption, ladies! Nobody "lets" you do this or can "make" you do that. Proper use of the word "no" can go a long way.
I think women need to be creative and come up with non-traditional ways to accomplish their purpose. If what you want

to do doesn't exist, create it. A woman doesn't have to work within rigid parameters, as may have been the case years ago. Now we have a new millennium where a president's wife has become a senator and may very well be the first truly viable female candidate for president. In Michigan, a woman has become president of one of the most conservative, private gold clubs in the state. Only a few years before, that same woman asked me to speak at a ladies' luncheon on how to cope with the turmoil caused by the passage of a bill that in essence, lifted restrictions banning women from playing golf at selected premium times. The men were fuming and chasing women, who had every right to be there, off the course.

And while I'm still on my soapbox, I just want to add this: Ladies, we can be very productive but still be feminine; we can get a point across without using foul language. It distresses me to hear the way many young women are talking today. Mom's soap would have been worn out on those mouths. And always remember this: Men are not the enemy. They are much better as allies. **—Janina Jacobs**

Janina is a multi-talented dynamic community leader. She is a golf columnist with the *Detroit Free Press.*

Did You Know...

Her name was Babe but she was more of a tomboy then a debutant. As a teenager, Babe Didrikson set out to be the best athlete of her time. She was accomplished in just about every sport—basketball, track, golf, baseball, tennis, swimming, diving, boxing, volleyball, handball, bowling, billiards, skating and cycling. It was reported that when asked if there was anything she didn't play, she said, "Yeah, dolls."

www.espn.com article by **Larry Schwartz**

Defining a Woman Today...
Women today are much more diverse, realistic and forgiving of themselves. A woman today finds strength in negotiating the societal demands. **—Heidi Van Arnem**

Heidi helped start her own foundation in 1992, dedicated to helping find a cure for paralysis. One of her greatest achievements has been building iCan.com, an Internet web page geared toward helping people with disabilities. "One of the fundamental reasons iCan was formed was to give back and help others recognize their strengths in life," explained Heidi. She passed away in 2002.

Did you know...
She couldn't pronounce her name as a child so Elizabeth Dole called herself Liddy and the name stuck.
And...
On her first day at Harvard Law School a man approached Elizabeth and asked her what she was doing there. He asked if she knew that there were men who would give their right arm to be at that school. "It was like having water thrown in my face," she explained.
Also...
Elizabeth Dole is known to have an enormous amount of energy. She keeps going and going. In fact, while on the campaign trail a woman asked Mrs. Dole where she got her energy. She responded by saying, "I get it from you. You draw the energy from the people you meet. They kind of buoy you along."
Excerpts from *Lifetime Television*'s "Intimate Portrait" of Elizabeth Dole, which 5-21-01

Defining a Woman Today...
I define being a woman as a person gifted with grace, the ability to charm and love. I think that the ultimate woman is one who allows God to make of her life what He will—even if it's unconventional—and a person who doesn't get caught up in the fact that I refer to God as "He." He's that main man in my life. **—Faith Green**

Faith is a 33-year-old African-American woman serving in ordained ministry. She is a former reporter and a Harvard graduate and says these experiences have enhanced her ministerial skills.

It Was Said...
 Faith is living an unshakable confidence, a belief in the grace of God so assured that a man would die a thousand deaths for its sake. —**Martin Luther**

Defining a Woman Today...
 In this day and age, there is not much difference in being a woman or a man. We are doing everything that men are doing. I would say that being a woman or good human being is being kind, being considerate, giving back to the community, believing in your dreams, having a fire in your belly and a passion in your heart, being the best you can be.
 I think that loving is very important, as is talking to people, being intimate not holding things inside and forgiving and forgetting. I think all of these things not only make up what a woman should be, but also what a good human being should be. Believing in yourself and your convictions making decisions knowing you can change if you have to and saying you're sorry when necessary is all so important. —*Florine Mark*

Along with being the president and CEO of The W. W. Group Inc., Florine is a motivational speaker, often speaking to diverse groups across the country. Prior to losing 50 pounds and keeping it off on the Weight Watchers Program, Florine tried every fad diet around, including a near fatal bout with diet pills. She often tells members she lost the same 50 pounds at least 10 times—which adds up to a whopping 500 pounds.

It Was Said...
 You don't have a compartment in your brain that is used to process this kind of elation and fear. Suddenly you have this wiggly thing that's sliming all over you, and you're not quite sure about it, yet. It's not as instantaneous as everyone

135

says... It makes somebody like me believe in all, in God, in the universe. It's entirely magical. And then you think to yourself, 'I can't believe they're going to let me leave with this baby. You mean I don't have to take a quiz or a test? I just walk out with it?' —**Camryn Manheim** Quoted in *Us Weekly*, April 23, 2001, talking about giving birth to her son Milo.

Defining a Woman Today...

I think it's sad that women seem to have to take sides on the issue of femininity vs. accomplishment. It's a totally false dichotomy. When I make a speech to a think tank or appear on "Meet the Press" with congressmen and senators, I still wear my most attractive clothes and have my hair done. I want to look like a woman, because I'm proud of being a woman—an accomplished woman. Why should a person surrender her bio-psychological core in order to be professionally successful? It isn't necessary, and it isn't satisfying. —**Dr. Laura Schlessinger**

Some have called her "America's conscience." Dr. Laura can be heard all over the country on her syndicated talk show. As she always says, "I'm my kid's mom."

Did You Know...

Dr. Laura has a very creative side and she puts it to use for abused and neglected children whom the Dr. Laura Schlessinger Foundation supports through its *My Stuff Bag Program*. Her jewelry making started as a hobby, but quickly turned into a funding stream for the foundation. She searches the world for fabulous antique ornaments, beads and natural stones, which she fashions into the most exquisite one-of-a-kind necklaces with matching earrings. In just one year the necklaces have generated thousands of dollars to ship duffle bags full of much-needed necessities and luxuries to forgotten children in crisis centers nationwide.

136

Defining a Woman Today...

Being a woman today has its blessings and its curses. The opportunities for women are wide open and the expectations are high. Yet, while there has been a women's movement, the rest of the world seems to be frozen in the Dark Ages. We still run businesses as if women will be home to receive services during business hours. We still expect women to avoid letting their family obligations rear their ugly heads in the workplace. When married women who work outside of the home have to go on business trips, other women will ask them, "Who will take care of the children?" as if their spouses did not exist.

The role of women today is to recast not their own roles, but to recast the challenges for men and institutions as they relate to raising families. —Desiree Cooper

Desiree, a former attorney, is a columnist with the *Detroit Free Press*. She is also a wife and mother.

Did You Know...

Sarah Payson Willis Parton, better known as Fanny Fern, was an author and America's first woman columnist. She wrote for the *New York Ledger* from 1855 until 1875.

Her paternal grandfather edited a *Whig* journal in Boston and her father is most remembered as the founder of the Youth's Companion in 1827, to which Sarah often contributed. She also wrote for small Boston magazines using the pseudonym "Fanny Fern."

In 1853 her journalist career caught the attention of publisher James C. Derby from Auburn, New York. He gathered her writings and published them as Fern Leaves from Fanny's Port-Folio and a series of Fern Leaves was published as well as Little Ferns for Fanny's Little Friends, a children's book.

137

Defining a Woman Today...

Today, a woman is someone who acknowledges the value of her own voice and her own view of the world and she expresses it. Unlike the revolutionary feminists and feisty black women I grew up with, she doesn't have to yell, scream or "lose it" to be heard. She simply reduces her own internal negative, reactionary thinking so her mind is positive, clear and focused. In that way, she can be calm and peaceful as she speaks her mind without fear. People listen. Men even listen.

As long as she can complete an education or training, which will prepare her for a middle-income career, she can make choices about whether or not she wants a male partner. She can choose whether or not she wants to accept a traditional, hierarchical relationship or one in which he is an equal or "consort." Regardless of partner choice, she can become a new creature: a woman who is secure and sassy, yet sane.
—Debra Ann Brodie, Ph.D.

Debra Ann is a 49-year-old African-American psychologist in private practice in Detroit, MI and founder of the Sisters and Daughters of Sheba ® love school for women and teen girls.

Did You Know...

Mary Wollstonecraft's A Vindication of the Rights of Woman (1792) was a classic early call for equality, a basic document in the fight for women's rights. (Library of Congress)

It Was Said...

Would man but generously snap our chains, and be content with rational fellowship instead of slavish obedience, they would find us more observant daughters, more affectionate sisters, more faithful wives, more reasonable mothers—in a word, better citizens. We should then love them with true affection, because we should learn to respect ourselves. —**Mary Wollstonecraft**, in A Vindication of the Rights of Woman (1792)

Defining a Woman Today...

A woman is confident in her abilities to achieve any goal(s) she sets for herself, from successful business owner to full-time "supermom." A woman is self-accepting—not bothered by the cellulite on her thighs or bad hair days. A woman is strong enough to climb mountains, yet gracious enough to appreciate a door being held open for her or a gentleman standing to greet her. —Darlene Zimmerman, MS,RD

Darlene is a 36-year-old wife, woman and girl living in metro Detroit. She is a registered dietitian running her own consulting firm. Life priorities include updating her new home and spending time with friends and family.

It Was Said...
Never bend your head. Hold it high. Look the world straight in the eye. —**Helen Keller**

Defining a Woman Today...

*I would say women still have an uphill battle being recognized as viable and important parts of society. Although we have come a long way in our freedoms, women are still paid less than men in the same job title, we are and still have to protect our rights to choose. We are dismissed in several fields because of our genders and when we do manage to break through, we have to work twice as hard to prove ourselves. I am proud of being a woman, and I'm glad to be a woman today and not 50 or 100 years ago. —**Christine McNichol***

Christine is a 31-year-old single female with no children.

It Was Said...
Happiness is to be found along the way, not at the end of the road, for then the journey is over and it is too late. Today, this hour, this minute is the day, the hour, the minute for each of us to sense the fact that life is good, with all of its trials and troubles, and perhaps more interesting because of them.
—**Robert R. Updegraff**

Defining a Woman Today...
Smart enough to know she can't be everything to everybody. Smart enough to get help when she needs it. Picks her battles very wisely. Knows that she is not perfect and God loves her and that's all that matters (and on a cold night alone that's a hard pill to swallow) works constantly not to compromise her values or God's values. Realizes she is a gift.

*There is also the woman today who is just trying to make it from day to day. She focuses too much on having a man, relationship, etc. Complains that she is too fat, too short, too dark, too light, etc. Is somehow incomplete with one of her parents (probably dad). Works a lot of hours to try to forget her troubles. Doesn't realize she is a real gift. Forgot the scripture "A MAN who findeth a wife findeth a good thing." Is always asking: "Why me?" "Why not me?" or "Please pick me." Has a hard time "JUST BEING." —**Charilyn Hackney Goolsby***

Along with being the president of mostly a one-man operation called Walter Goolsby Enterprises, a full-service advertising specialist company in Detroit, Charilyn describes herself this way: "I'm Charilyn Hackney Goolsby, but everybody calls me Char. It kind of pisses off my mother as she insists that she did not name me 'Char.' I think my 'white' friends started that 'Char' thing, but it's OK. I am a married mother of a wonderful daughter named Lauren Michelle. Because, I am Charilyn, also known as Char—wife, mom and child of God."

Did You Know...

We all know that Rosa Parks became the Mother of the Civil Rights Movement after 1955 when she refused to give up her seat on a city bus to a white passenger. But there are many African-American women in history who fought for freedom, like Sojourner Truth, born Isabella Baumfree in 1797 in Kingston, New York.

She was the first black woman orator to lecture against slavery. In 1827, she escaped from her master, who sold all five of her children. Eventually, with the help of a Quaker family with whom she lived, she won a lawsuit to get one son back. She could neither read nor write but she became a legendary preacher during her time. Her stature empowered her as well. Standing six-feet-tall, she commanded respect from those who heard her speak.

Defining a Woman Today...

Today, I think of a woman as one of two types of humans. One type is not better than the other and there are no stereotypical roles. If a woman wants a career, that is her choice. If a woman wants to stay home with her family, that is also her choice and one choice does not make her a better woman. Society has put enormous pressure on women to have a career and be the "supermom" of the 1950s, like my mother was. This can't be done by one human, but we keep trying and women suffer from never feeling like they are not doing anything to the best of their ability. —Cathy Collins-Fulea, MSN, CNM, FACNM

Cathy is a nurse midwife.

It Was Said...

The child feels the drive of the Life Force...you cannot feel it for him. —**George Bernard Shaw**

Defining a Woman Today...
Women, like men, are not defined by their gender. Rather, they are defined by the kind of people they are. We are all defined by our relationships with others. We're defined by our ethics, and by the contributions we are willing to make, either for our society, our workplace or our family. We are defined by the respect we show others. —**Candice Miller**

Candice Miller was the first woman elected Michigan Secretary of State and the first woman elected Harrison Township Supervisor and Macomb County Treasurer. She was elected to Congress in 2002.

Did You Know...
A young Czechoslovakian immigrant who came to the United States at 10 years old became the highest-ranking woman in the history of the U.S. government. Former U.S. Secretary of State Madeline Albright's family had to flee Czechoslovakia twice; first, when the Nazis overran Czechoslovakia in 1938, then to the United States when the communists seized power 10 years later. Her father was a Czechoslovakian diplomat, so as a young girl, Madeline learned to greet visiting European dignitaries with flowers and a smile. She discovered her natural roots upon becoming the first woman U.S. Secretary of State. Madeline was raised Catholic but family records showed that she in fact came from Jewish ancestors.

It Was Said...
When I work, I really work. I rub my eyes and my makeup comes off, and I stick pencils in my hair.
—**Madeline Albright**, to the *New York Times*

Defining a Woman Today...
Being a woman today means "the sky's the limit." I aspired to be a secretary 40 years ago and thought that was a monumental aspiration. Women today can be and do anything they want to, including being the president of the United States

142

and flying to the moon. For me, being a woman means being able to express myself openly and honestly; it means being a working wife, mother, grandma and daughter who can effectively, and with love, manage all these roles. —Bernice Carter

Bernice is a 60-year-old wife, mother of one son, a grandmother of one and a breast cancer survivor. She is employed full time at a foundation that focuses on awarding scholarships to Detroit's underprivileged youth.

It Was Said...
I talk to the cat differently now. The birds are singing more sweetly, and the foxes don't scare me. Everything has slowed down. Cancer does that to you. That's the first of the blessings. —**Suzanne Summers**
Quoted in *People Weekly*, April 30, 2001, in an article on her battle with breast cancer.

Defining a Woman Today...
My answer seems to lean toward "personhood" rather than "womanhood." Being a woman means having the ability to do anything one wants to do—motherhood or not, career or not, education or not. I think the pendulum has swung back a ways from the era of "Superwoman," where women felt they could, and in fact had to, "do it all." I think women today are finding more balance in their lives. We don't have to prove as much as we once did, which allows us to concentrate on being who and what we are—being true to ourselves. So I would define being a woman today as having unlimited opportunities, and the opportunity to do all the things that are important to us.
—Anne Miller

Anne is a 38-year-old married woman with an adopted daughter. She is working as an estate manager.

143

It Was Said...
We won't always know whose lives we touched and made better for our having cared, because actions can sometimes have unforeseen ramifications. What's important is that you do care and you act. —**Charlotte Lunsford.**

Defining a Woman Today...
Being a woman today, as in any other era, certainly presents its challenges. I think being a woman today is about being strong and assertive without sacrificing your femininity to do it, which can sometimes be a delicate balance. It's about being confident and smart and kind and loving. It's about taking care of yourself emotionally, physically and spiritually. It's as complicated as it ever was, but the good news is that you can wear a great pair of shoes while you figure it out.
—*Ann M. Delisi*

Ann is an Italian, passionate woman who loves to laugh, loves to learn and is hard working. Along with hosting *Back Stage*, a talk show on Detroit's local Public Television, she has worked in radio for years. She also loves music and has "spent [her] life surrounded by it."

Did You Know...
It was the first TV series to center around the exploits of a single and independent woman and it was on that show that Marlo Thomas became a household name playing Ann Marie in 1966 on the hit show *That Girl*. What you might not have known is that the woman born Margaret Thomas in Deerfield, Michigan, actually became a teacher before pursing an acting career, despite being surrounded by a high-profile world of theatrics in her youth.

Defining a Woman Today...
Strong enough to handle anything, yet sensitive to almost anything. Capable to do whatever it takes to get the job done. It seems most of the women I know are fiercely independent,

self-reliant and strong willed on the outside but still dedicated to their family. —**Andrea Bedard**

Andrea is described as a hard-working, dependable, self-reliant, intelligent and sensitive all at the same time. She says, "I can do anything I put my mind to."

It Was Said...

We are taught you must blame your father, your sisters, your brothers, the school, the teachers—you can blame anyone, but never blame yourself. It's never your fault. But, it's always your fault, because if you want to change, you're the one who has to change. It's as simple as that, isn't it?
—**Katherine Hepburn**

Defining a Woman Today...

As an adult, I feel that a woman is someone who is responsible for herself (with or without children), financially independent, and makes decisions based on experience, and asks for advice when necessary. —**Amy Schooley**

Amy is a 39-year-old woman who has been married more than 10 years and has a 7-year-old daughter.

It Was Said...

Marriage is not just spiritual communion and passionate embraces; marriage is also three meals a day, sharing the workload and remembering to take out the trash. —**Dr. Joyce Brothers**

Defining a Woman Today...

A woman today is so much more than her mother or grandmother was. It is so exciting when I think of all the opportunities that my daughter will have in her generation.

The unfortunate part, however, is the fact that women take

on a lot more roles today than ever before. The pressures are greater. Women work and raise families. They function in traditional family units or as single parents. Women also strive for more education and other activities outside the home. There really are no limits. I do not find that men need so many different roles in their lives the way women do. —**Lisa Patrico**
Lisa is a "30-something" wife and mother of three children and helps run a family business.

Did You Know...
 In 1975, The National Women's Health Network was formed in Washington, giving women a voice in health policy and legislation. Six years later a spin off was launched—the National Black Women's Health Project.

Defining a Woman Today...
 An individual, varied and complex. —**Lois Teicher**

Lois is a professional sculptor who has completed outdoor public art projects.

Did You Know...
 Margaret George joined the *Kurdish* resistance movement in northern Iraq in 1961 at the age of 20 and because of her bravery and leadership skills, she was able, within a short period of time, to assert herself as a capable commander. Throughout her eight years of active combat service, she was to take part in numerous campaigns, notably the battle of *Zawita Valley.*
 Margaret lost favor within the *Kurdish* leadership when it became clear to them that she had Assyrian higher interests in her heart. She was killed on the night of January 26, 1969 while asleep at the village of *Kala-Komereyh.*

Defining a Woman Today...

As a woman from the Middle East, I define a woman in these countries, although I live in America now. Their rights are constantly insulted and violated. I feel sorry for women in these societies who suffer as victims of negligence and experience loss of rights. They used to suffer in dark times of slavery, under the excuse of preserving traditions.

Today, I appeal to all the international organizations in the human rights to help our women to live decent lives and to oppose regimes that use power to oppress and humiliate their women for no other purpose than to stay in power.

I define a woman as cultivating ideas of true value for the future and encouraging the spirit of coalition, peace and nonviolence in our lives. I believe in the good words said by a famous Iraqi poet Alrusafi: "Mother is a school. If you take care of her, we will get a good generation." Woman can change society because they are the ones raising the next generation. **—Katrin Michael, Ph.D.**

Katrin has been interviewed all over world, including by ABC's Barbara Walters. She is a victim of Saddam Hussein's chemical weapons. As an Iraqi woman, she fought for freedom against the Iraqi regime in 1988. She currently works in Washington, D.C., as a researcher.

It Was Said...
Much of your pain is the bitter potion by which the physician within you heals your sick self. **—Kahlil Gibran**

Defining a Woman Today...

It is not easy to give a definition. A woman is a human being. There are not many differences when compared with a man, but there are some characteristics that make a woman different. A woman experiences death. My approach to giving birth is close to dying. This is an experience only a woman has. It is the existential possibility of a woman. It is the main reason why women have multidimensional understandings and

147

integrate into the world. They are not better, but different. Men have other possibilities and characteristics. The differences between us allow women to integrate into life and to love. It gives a woman the possibility to be more universal. A woman has substance. —Maria Piniou Kalli, MD

Maria is President of International Rehabilitation Center for tortured victims in Denmark. She is also a dermatologist in Athens, Greece.

Did You Know...
The first female doctor in the United States was admitted to New York's Geneva College as a joke. Elizabeth Blackwell, born in Bristol, England, in 1821, overcame prejudice and graduated with honors in 1849. She and her sister Emily founded the New York Infirmary for Indigent Women and Children in 1853. It had a medical staff made up entirely of women and the clinic later became a medical college for women. Elizabeth eventually returned to England where she established the National Health Society of London and the London School of Medicine for women. At the end of her career, she became a professor of gynecology.

Defining a Woman Today...

Being a woman today means being smart and strong when you have to, and soft when you can. Smart and strong in business, or when in harm's way. Soft when in the presence of someone who truly cares about you. Smart, strong and soft all blended together, like complex spices in a great sauce. That's being a woman to me. —Maureen Electa Monte

Maureen is a determined woman, obsessed with excellence and stifled by rules. She says, "I like myself, but don't think I'm easy to love. Maybe someday?" She is also a photographer and author of *Letters to Heaven*.

Did You Know...
 In 1970, the female body became less of a mystery when Carol Downer and associates introduced gynecological self-exams, with a spectrum and mirror, at the Feminist Women's Health Center in Los Angeles. It was the first time that women were able to see firsthand what goes on in this region of their body simply known to them as "down there."

Defining a Woman Today...

A woman today is a perfect mix of sexuality, independence, confidence and compassion! If there is one thing I have learned over time, it's that women have more in common than they want to admit, both good and bad.

Those stereotypes exist for a reason. I used to describe myself as special and different. Although I still think that, I now know that what makes me special and different is the same things I have in common with all women. In other words, I am sexual, independent, confident and compassionate all in my own special, different, perfect mix. I am also very proud to be a woman and share these complex qualities with my sisters.
—Michelle Hobson

Michelle is married and lives in Germany.

It Was Said...
 If you have to support yourself, you had bloody well better find some way that is going to be interesting.
 —**Katherine Hepburn**

Defining a Woman Today...

It is a powerful thing, and you can have tremendous respect from others. You can do anything you want to do. I just wish I had more "role models." We didn't have ESPN or USA Today—only what we saw locally on TV.

How exciting is it to know you can be a professional basketball player. You can be a golfer. You can turn on the TV today and watch the women's World Cup and the women's USA team playing on network TV. We are so respected today as business leaders, as role models, as athletes, as women in politics, as women in science—you name the field and we're respected. **—Nancy Lieberman**

Nancy is 3-time All-America and 2-time basketball Player of Year (1979-80). She led Old Dominion to consecutive AIAW titles in 1979 and 1980, played in defunct WPBL and WABA leagues and became the first woman to play in a men's pro league (USBL) in 1986. She also played in the inaugural season of the WNBA for the Phoenix Mercury and served as coach/general manager of the Detroit Shock from 1998 to 2000.

It Was Said...
Leadership is similar to teamwork. You have to remain centered, be mindful, assess a situation, bring people together, come to an agreement, and discover solutions by using the talents of everyone involved. **—Unknown**

Defining a Woman Today...
Being a woman is something so powerful and meaningful. A father and son are the brawn and successor of a family and its following generations, yet a mother and daughter are the heart and soul of a family, alert to human dignity and respect of an individual. Being a woman means not only having the physical ability to propagate the family unit, but also the moral strength, honesty and courage to elevate humanity to the highest awareness of kindness and compassion. **—Nicole Rashid**

Nicole is a "20-something" radio producer based in Michigan. She worked for the syndicated *Mitch Albom Show* as an assistant. She also worked one year on the *Jerry Springer* show in Chicago as an assistant producer.

Did You Know...
 That according to the American Heart Association, 42% of women will die within one year of having a heart attack compared to 24% of men?

Defining a Woman Today...

You define being a woman by going through life. You change that as you change because what is important to you changes. That is how it should be. We live in a culture where people often don't want to change. In this culture, if you said at 10 years old that you wanted to do something, you have to do it forever. That changes.

At 25, if you want to be a mom you can, and at 40 you may decide you want a career or vice versa. You may decide at 25 you want a career and at 40 you want to be a soccer mom. Maybe you were an attorney and all of the sudden you decide you want to be a schoolteacher. We live in a place that doesn't support people evolving and growing as a person. I think for women, because we are so in touch with our feelings, it is part of who we are—our identity—is recognizing these changes.

What we have to do is grow and mature and learn to embrace the changes and say it's okay. It's like the saying "When I am old, I shall wear purple." Why don't we do that when we want? If you want to wear purple with a red hat, you shouldn't care what people think of you. How do we embrace that at a younger age? —Pam Johnson

Pam Founded the Secret Society of Happy People and wrote the book, *Don't Even Think of Raining on My Parade.*

It Was Said...
 If I could wish for my life to be perfect, it would be tempting but I would have to decline, for life would no longer teach me anything. —**Allyson Jones**

Defining a Woman Today...
A woman today is a person with many opportunities equal to men, such as having a career or being a wife and mom or some combination. **—Pam Wallace**

Pam says she is a mature, happy woman because of her husband and son.

It Was Said...
I love the challenge of starting at zero every day and seeing how much I can accomplish. **—Martha Stewart**

Defining a Woman Today...
Doing anything she sets her mind to do, whether it be work outside or inside the home, volunteering, going to school being married or unmarried, having children or not having children by choice.

Sharing all household tasks (with children and spouse, if applicable) or paying for some of these chores. Sharing in decisions about the children. Sharing in the car-pooling of all children events. Sharing of all business decisions in family/household matters.

A woman is never being alone, unless by choice, in any situation good or bad, and always knowing that God is there with her. **—Patti Alef**

Patti is a wife and mother of three children and is working outside the home.

It Was Said...
I wanted to be scared again...I wanted to feel unsure again. That's the only way I learn, the only way I feel challenged.
—Connie Chung

152

Defining a Woman Today...
A highly intelligent individual, ready to roll up her sleeves and tackle whatever challenge is laid at her feet. —*Paula C. Laroway*

Paula is a 50-year-old repair technician for a phone company, has 10 siblings, is a mother of three, a grandmother of one, a two-time divorcee, an active church member and a coach for girls sports.

Did You Know...
Gertrude Elion, pioneer researcher and Nobel prizewinner helped develop the first drugs to combat leukemia and herpes effectively and oversaw the development of AZT, used to treat AIDS.

Defining a Woman Today...
I think being a woman today means you can have it all. There are so many options available to women. They can work or stay home or go to school. The women that have to work still have a lot available to them. More companies are family oriented because they need to be in order to keep good employees. —*Beth Louzon*

Beth is a part-time working mom and has been married to her high school sweetheart for 20 years.

Did You Know...
If you do a search on the Internet you can find tips and 10 steps on how to be more like June Cleaver, Beaver's mom. It may not be politically correct or even accepted, let alone admired, anymore, but if you want to be more of a traditional woman, new age technology lets you search the World Wide Web and find out how.

153

Defining a Woman Today...
*Someone who can laugh through her tears and cry with joy
and who recognizes only the limits she sets for herself.* **—Peg
McNichol**

Peg is a 43-year-old divorced mother of two and a journalist.

Did You Know...
Her name may sound like it comes from traditional Irish
folklore to the average American ear, but the name Roma was
actually made up. Roma Downey's mother wanted to include
the names of Roma's two grandmothers, Rose and Mary, and
by combining the names she came up with Roma. When her
parents went to baptize her, the priest asked what her name was
and didn't think Roma was appropriate for a Catholic girl, so
when her mother explained how she came up with the name,
the priest said, "We baptize her 'Rose Mary' and you can call
her anything you want."
Aired on *Lifetime Television*'s "Intimate Portrait" with
Roma Downey

Defining a Woman Today...
Today's woman says, "I can do that," and she does!
—Rachel Nevada

Rachel is a co-host on the syndicated *Mitch Albom Show*.

It Was Said...
If you admire someone instead of noticing the ways you
don't measure up, you notice the ways in which you are
similar. We really admire only people who reflect an image
of what we already know is the best in ourselves. Train
yourself to see what is similar! **—Unknown**

Defining a Woman Today...

A woman today is independent, makes her own decisions, and can do things in life without the help of a man. A woman today has many more opportunities than years ago. Women today have perseverance. They want to prove to themselves and everyone else out there that they, too, can succeed in the professional world. **—Anna Elizabeth**

Anna is a 25–year–old elementary school teacher.

It Was Said...
The pleasure you get from your life is equal to the attitude you put into it. **—Unknown**

Defining a Woman Today...

I have this quote in my show: "Woman are trained to see themselves as cheap imitations of fashion photographs rather than seeing fashion photographs as cheap imitations of women." It's a struggle to not hold yourself up to some media ideal. It's hard not to compare yourself to anybody.

I think a real woman continually celebrates her own unique qualities (personality and talent) and does not just focus on physical attributes. I revel in the fact that we are not all supposed to be the same size or look the same way. I feel beautiful, feminine, strong, worthy and womanly on stage. My goal is to feel that way in my day-to-day life. **—Rose Abdoo**

Rose Abdoo is an actress and a storyteller who has traveled the country performing several one-woman shows, including the award-winning *Get to the Part About Me*. She has appeared in several television shows and motion pictures. You might remember her as a seamstress in *My Best Friend's Wedding*.

Did You Know…
After winning an Emmy in 1962 for a comedy variety show on *The Garry Moore Show*, CBS offered her a lucrative 10-year contract. Carol Burnett was paired with fellow singer/actress Julie Andrews in a special TV production, "Julie and Carol and Carnegie Hall." The show also won an Emmy.

Defining a Woman Today…
*Three simple words—but only if you really mean them—strong, confident, and self-fulfilled (these surely include love, children and the ability to give of yourself). —**Ruth Mossok Johnston.***

Ruth says, "My professional adult hats are as varied as those in my closet: published author, food critic, columnist, recipe developer, educator, freelance writer, wine program coordinator, PR specialist, brand manager (The Johnston Collection), art agent, and designer—and these are on a daily basis. These are my interests and passions."

It Was Said…
In the final analysis, it is not what you do for your children but what you have taught them to do for themselves that will make them successful human beings. —**Ann Landers**

Defining a Woman Today…
*I would define a woman today as living your dream and not being defined by someone else. I haven't been in a relationship since I have been clean. I always had to have a man to validate who I was. Today, I have a lot of friends but I don't need a male in my life to validate me as a woman. Don't mistake my confidence for arrogance. My addiction taught me arrogance and my recovery has taught me self-confidence. —**Sarah Dean***

Sarah is a former heroin addict who now helps others kick the habit.

Did You Know...
When Cindy Lauper was in convent school, she was expelled after asking a nun if she had started her period. It was an innocent question from an inquisitive kid, and she was punished for it.
Information aired on *Lifetime Television* 2002

Defining a Woman Today...
A woman today has to be able to care for herself financially and emotionally. Above all, she has to have a strong sense of self-esteem that empowers her to meet her needs and not just be a caregiver for those around her. **—Sheila White**

Sheila, 52, obtained her master's degree in social work at the age of 40. She works in the mental health unit at a Metro Detroit area hospital and has been married twice. She says she is a feminist and feels fortunate to have a strong network of female friends. "I have come a long way since the death of my first husband," said Sheila.

Did You Know...
In 1980, a transit strike forced New Yorkers to walk to work and a trend started; thousands of working-women replaced their heels with sneakers.

Defining a Woman Today...
A woman today is blessed with self-assuredness, self-confidence, a positive attitude and a strong sense of faith. Idealistic? No. Reality based? Yes. But, I've got a long way to go. A woman today should be a queen. **—Shelly Irwin**

Shelly says that change can be a good thing and she's living it! Having spent 15 years in the health care field, she is embarking on a career change and entering the broadcast journalism field. "Life is short and I believe in following one's dreams," Shelly says. She describes herself as spunky, self-disciplined and dedicated. She is a licensed physical therapist and adds that she is blessed with good health, a supportive family and two needy dogs, allowing for a fairly positive persona!

157

It Was Said...

There are three types of people in the world: ones that watch things happen...ones that make things happen...and ones that wonder what the heck happened! —**Unknown**

Defining a Woman Today...

Being a woman today means having the ability to take care of your home and children with the help of your spouse, also helping to earn half the living. You are an independent person who can do anything a man can do. That's why I think that women and men should forget about the gender thing and look at people for who and what they are and have to offer. If it were at all possible, I would like to stay at home with my children until they are in school. I don't think that makes me less of a woman; it has always been my dream to raise my children and be there for them. I want a husband, though, who will be a wonderful father and spend quality time with our children. I would like to continue with my career once my children get old enough to be in school full time. I just want to be a happy person and fulfill my dreams. —Shelly Yono

Shelly is a 26-year-old woman who put herself through college and now works full time while getting a master's degree in education. She hopes to be an elementary school teacher.

Did You Know...

Over a lifetime of work, the average 25-year-old woman who works full time, year-round until she retires at age 65 will earn $523,000 less than the average working man.

Defining a Woman Today...

You can be anything you want to be. It is totally up to you. Happiness comes from within and fulfillment comes from within. However, if you are a woman, you have to want it bad enough. It's not going to be as easy for a woman to be who she

wants to be as it is for a man. It depends on what field you go into. Some fields are more acceptable for women. It is getting easier to break into what is perceived to be a man's field. I really believe we can all be anything we want to be. The only reason I am not president of the United States is, obviously, that I didn't want to be. If I really wanted to be the president and was willing to shut out the rest of my life, I believe I could have been the president. —**Sherri Robinson**

Sherri married, had two daughters, divorced, then married her high school sweetheart.

It Was Said...
You cannot control another person. You can only control how they affect you. —**Unknown**

Defining a Woman Today...

Today, we do everything. We have a job. We take care of children. We run a home. We combine everything. And, I think we do it very well. I have a lot of women asking me, "How in the world did you combine a career, like you had, and raise three sons? How did you do it?"

The key is priorities. My sons, until they were school aged, went everywhere with me. They went to Europe on movie locations. I always had a nanny. I always had someone else to help to take care of the kids. Some young women today will say, "I am going to do everything myself. I don't need a nanny. I don't need anyone else." That is a mistake, I think. If you are going to work, you either have to have someone there to help you or you are going to have to work less. My children were my priority.

If I had a movie, I would arrange it so that I was home for every single birthday, every Christmas, every holiday, every baseball game. When they were school aged, I did The Partridge Family *for five years and one of the reasons I did that*

was so I could be home with my kids. Every agent and every manager said that was a big mistake because at that time doing television was a step down for a movie actress. —**Shirley Jones**

Every generation knows Shirley, either from her movie career or from *The Partridge Family*. Thanks to networks like Nickelodeon and American Movie Classics, people young and old know Shirley Jones. "It has worked out well because I have been able to go from one medium to another rather successfully, says Jones. "That is what has given me longevity in this business and I am still working."

Did You Know...

More than 30 years later, *The Partridge Family* and the cast of characters are still a colorful topic—just check out the dozens of websites dedicated to the show or reruns on television. You could be wondering: whatever happened to that colorful bus from the Partridge Family? According to the writers at the website www.cmongethappy.com, reliable sources uncovered that the actual bus lived for years behind Lucy's Tacos on Martin Luther King Blvd., right by USC. However, in February 1987, the bus was sent to a junk yard. Sources report that it was in horrible shape—windows broken, tires flat, all identifying type (such as the family name on the side and the "Caution Nervous Mother Driving" sign on the back) was painted over in white and the rest of the bus was faded.

Defining a Woman Today...

A woman is whomever she wants to be as long as SHE is the one defining her own role. She has learned to step out of her own way on the path to what will fulfill her. She could be a teacher, an engineer, a doctor, a secretary, a writer, a lawyer, a stay-at-home mom. As long as she is doing what she—not society, and certainly not her husband or parents—wants her to be. —**Theresa Falzone**

Theresa Falzone is a writer, publisher and editor in the metro Detroit area.

It Was Said...
I try to understand my children, not teach them. To direct
them. If Eugenie comes back from school and she's very
angry and starts dropping things or being cross, I might say,
'Well, what happened at school today?' instead of 'Why did
you drop that, you naughty girl? ... I've broken a pattern. I'm
so proud of that. I have no confidence really in anything but
my children. —**Duchess of York, Sarah Ferguson**
Quoted in *In Style* Magazine, December 2000

Defining a Woman Today...
*The woman of today is independent and self-sufficient. She
knows that with the breakdown of society and ever-changing
social mores that it may be unrealistic to expect a man to take
care of her. She has to learn how to take care of herself.*

*Therefore, she may elect to go to school to prepare to get a
degree so that she can become financially secure. Her "knight
in shining armor" may never arrive to carry her off on the
white horse into the sunset to live happily ever after. She may
not ever get the house with the little white picket fence. And
then, too, even if she does get married, her husband will
probably expect her to work outside of the home so that their
nuclear family unit (husband, wife and 2.5 children) will enjoy
a higher standard of living.*

*In the event that she doesn't get married, she will probably
strive to become financially savvy, learn how to save and
manage her money and even grasp the importance of investing
her money in mutual funds, treasury bonds or the investment
vehicle of her choice. "Putting her nuts away for the winter,"
so to speak, will enable her to live well during her retirement
years and also allow her to travel, or do whatever strikes her
fancy when she no longer has to work full time.*

*The woman of today is well educated, well versed and well
read. She is knowledgeable about the world around her and is
interested in current events. She is truly interested in other*

people and their cultures and strives to be a citizen of the world. She realizes that learning does not end when she finishes school, but is a lifelong process. She embraces all learning venues as a God-given opportunity to continue to excel. —Vanessa C. Hines

Vanessa is a descendant of Mother Africa, a public servant and a college graduate. She is the mother of three children, ages 16, 14 and 6. "And honey," she says, "I am a SURVIVOR!"

Defining a Woman Today...

That is a really hard question. I think it means having an equal marriage in which both parents take the responsibility equally in raising children, and that marriage means you respect each other and let each other go after one another's own dreams. —Kimber Bishop-Yanke

Kimber is the founder of Girls Empowered, an organization that offers programs to girls of all ages. The programs focus on self-respect, self-confidence personal empowerment and positive body image, as well as ways to achieve optimal health.

Did You Know...

She is hailed as one of the great voices of contemporary literature and is a remarkable Renaissance woman. Maya Angelou is not only a poet, educator, historian, best-selling author, actress, playwright, civil rights activist, producer and director, but she also became the second poet in U.S. history to have the honor of writing and reciting original work at a presidential inauguration. She did that in 1993 for President William Clinton.

Defining a Woman Today...

Today, being a woman is pretty much open ended. I really feel that being whom and what you are is what being a woman is all about. Being really true to yourself in spite of the expectations of friends, family and society. —Wendy L. Gorski.

Wendy is a 41-year-old married woman and mother of a son named Eric. She suffers from chronic depression, and because of her illness she works at home while being a full-time mom. She enjoys gardening, cooking and her family. "I don't believe in stereotypes for women or men. I am always trying to be a better person by making up for my past mistakes," she explained. "I enjoy the company of others who have differing opinions and beliefs; it makes for an interesting life. I really believe we are all individuals who can make a difference in the world by being who we are and standing up for the principles that we believe in."

It Was Said...
True happiness...is not attained through self-gratification, but through fidelity to a worthy purpose. —**Helen Keller**

Defining a Woman Today...

My definition of a woman today is one who knows who she is and where she is going—not just looking in a mirror, but also reaching within her soul. Being responsible and accountable for her actions. Today's woman has to be versatile and flexible in her personal life, work life and social life. She is a go-getter. Women are assuming roles in more areas more today than ever before. They are single parents, have professional positions in the work force and are seeking a higher education. —Yvonne Harper

Yvonne is a "50-something" woman working full time with children.

Did You Know...
In 1984, The U.S. women's basketball team won its first Olympic gold medal.

Defining a Woman Today...

Difficult—depending on what age you are. Women today are being fired from TV jobs when they get past the age of 40. That is very difficult to see. You work your whole life and it all comes down to whether you are pretty or not, and that makes me very unhappy.

I look at the other side of it now. I went to some WNBA games and at the first one, I walked into that arena in Washington and the place was packed. There were little girls with blue and white faces and I thought I would never see the day this would happen.

So, what is good about being a woman now is that even though it's too late for me to do what I wanted to do in this business, there are little girls, 10 and 11, who send me their tapes every day. They all talk too fast, just like me, and some have a little bit of a Boston accent. I was on Broadway for 15 years before doing this. This is as far as I am going to go. I am getting old and it is almost someone else's turn. If I were 20 and starting now, it would far different than starting at my age.

—*Suzyn Waldman*

Suzyn, announcer for a professional baseball team and reporter for New York's Leading sport radio station, WFAN, is one of the few females who has broken into the male-dominated profession of sports broadcasting. She is the first woman ever to do play-by-play announcing and color commentary for Major League Baseball. She is also a breast cancer survivor.

Did You Know...

Baseball trivia: How close was the movie *A League of Their Own* to the people and events of the All-American Girls Professional Baseball League, which lasted from 1943-1954? The main character, Dottie Henson, played by Geena Davis, was a fictionalized character, yet she was similar to some of the catchers in the league. There were several sisters who played but many used their married names. Some people believe Davis' character most resembled player Mary Baker, who did have a sister, Gene McFaul (George), who played in the league, but the relationship of the sisters in the movie wasn't based on Baker and her sister. What was real: The women really did play in skirts; they had chaperons and were required to take etiquette classes.

Defining a Woman Today...
It is wonderful to be a woman. Women are creative, good fighters, hard working, play sports, are educators, serve justice, and appreciate their sex. They are free in appearance and know how to face reality. —**Ionna Karatzaferi**

Ionna lives in Greece and spends a few months each year in New York, where she lived for many years. She is the author of 18 novels, four books of short stories, seven books for children and teenagers, and has translated more than 20 books from English to Greek. She is also a columnist for the culture section of the Sunday edition of *Aggelioforos tis Kyriakis* (The Sunday Messenger), a Greek newspaper. She has been active with the Women's Movement for Equal Rights, and the Peace Movement.

Did You Know...
In 1909, Selma Ottilia Lovisa Lagerlof, a Swedish schoolteacher, became the first woman to receive the Nobel Prize for literature.
And...
The Nobel Prize is the first international award given yearly since 1901 for achievements in physics, chemistry, medicine, literature and peace. The prize consists of a medal, a personal diploma and money.
Also...
In 1968, the Sveriges Riksbank (Bank of Sweden) instituted the prize of economic sciences in memory of Alfred Nobel, founder of the Nobel Prize.

Defining a Woman Today...
I believe that women in general are now living in a very good moment in the history of the world, but they must keep fighting for their rights. So as not to be just "the cook" or "the maid" of any change or revolution, she must be always in "the front lines" and take charge all the time. We always see that when there is a war, the ones that suffer most are the mothers. They give birth to children so others can send them to kill or be killed. That's very painful. —**Mercedes Sosa**

Mercedes is an artist, not an "entertainer." She is also a great singer, but, above all, she always provides direct support to programs and projects that promote the political, economic and social empowerment of women in developing countries. She wants to link the needs and concerns of women to all critical issues on the global agenda.

It Was Said...
"Glamour" is assurance. It is a kind of knowing that you are all right in every way, mentally and physically and in appearance, and that, whatever the occasion or the situation, you are equal to it. —**Marlene Dietrich**

Defining a Woman Today...

I look at my three-year-old daughter all the time and wonder what kind of woman she will grow up to be. I try to be an example to her, and I know she is watching me very closely as I rush to the airport, appear on television, and even travel back to Iraq to help rebuild the country.

She will be coming with me to Iraq, and I think it will be an eye-opening experience for her, after growing up in the comfort of the United States. The other day, I saw her lining up her dolls in her room. When I asked her what she was doing, she told me: "I'm taking them to Iraq, to bring to the kids."

I think the challenge for all mothers, and particularly American Muslim mothers, is to teach both self-respect and tolerance. I grew up with so much hate around me, with so much emphasis on difference. We need to raise a new generation that does not focus on difference, but instead sees a common human bond. I think women are key to this process, both as mothers and as activists.

A woman is someone true to herself—as a daughter and a mother and a wife—and someone dedicated to empowering people of all backgrounds to be free and safe. —Zainab Al-Suwaij

Zainab is the co-founder and executive director of the American Islamic Congress (AIC), a social activist organization founded in the wake of September 11, 2001, to foster tolerance, promote civil society and civil rights, and mobilize a moderate voice in the American Muslim community. Zainab was born in Basra, Iraq, in 1971. And despite the societal pressures women face in the Arab and Muslim world, she is an outspoken social activist and positive voice within her community.

Defining a Woman Today...

According to the American Heritage Dictionary, *a woman is 1. An adult female human being. 2. Women collectively; womankind. 3. Feminine quality or aspect; womanliness 4. A female servant. 5. A mistress; paramour.*

Some of those definitions should be banished, yet there is so much missing from the dictionary.

I think that today many women feel their natural instincts are to nurture, make peace and serve are cumbersome. For some women, these are aspects of their very being that they work hard to hide. They think that if they allow them to come out and grow, they'll be viewed as weak and, worse yet, an embarrassment to their sex.

But there is nothing wrong with throwing like a girl!

I am fairly certain that if men had these priceless gifts, they would do nothing to try to hide them. Rather, they'd make every effort to capitalize on them, nurture them, use them to their advantage, and guard them like a secret handshake! The title of the bestseller would be "Men Are From Venus—So Are Women, But They Won't Admit It." Women who I feel are accomplished, secure and successful are able to take their instincts and make them a natural part of their life.

These women never allow these aspects of their being to become the sole focus of their lives or use them as a bargaining chip. Instead, they bestow the rewards of these unique gifts on themselves, family and friends. —Marie Osborne

Marie is a broadcaster at WJR 760 AM in Detroit, Michigan. She is a wife and mother of three children.

It Was Said...

I started out as a little black girl in little...North Carolina and now I sit next to Barbara Walters. The sky is really the limit.... And you know it's bigger than you because this was not my plan... If anyone doubts the existence of God, say hello to me. —**Star Jones**

Speaking on *Lifetime Television*'s "Intimate Portrait," which aired May 22, 2001

Defining a Woman Today...

There are so many definitions of womanhood floating around in today's society that it makes me dizzy. We're told that we have to be sexy. We're told that we have to be tough. We're told that we have to be better, smarter, faster and superior to men in every respect. And, we're told to stamp out every last bit of our femininity until what's left is totally contradictory to the creatures God intended us to be in the first place. I'm not saying that a woman can't be sexy, strong and smart. In fact, every woman should strive to be all of those things.

But, according to my definition, a woman cannot truly embrace her womanhood without celebrating her femininity— the very thing that makes us unique. Being feminine isn't about being weak or submissive. It's about being comfortable in your own skin, being proud of your complex nature. Can a woman single-handedly conquer the universe in a black leather cat suit while riding a motorcycle?

Sure, when she has to. But can't she also win a man's heart—and that of her family's—by being gentle, compassionate, nurturing and beautiful? With so many mixed messages, I can only imagine how adolescent girls must struggle when trying to define themselves. And now that I'm pregnant with my first child—a baby girl—I wonder how society will define women in the years to come. I can only hope the lines between men and women do not become blurred

beyond distinction. —**Jennifer Harrison-Stang**

Jennifer Stang owns a freelance writing and editing business in Livingston County, Michigan.

It Was Said...
Courage is the most important of all virtues, because without it we can't practice any other virtue with consistency.
—**Maya Angelou**

Defining a Woman Today...

Recently, I spoke at a Catholic women's conference titled, "The Lord Has Done Great Things for Me—Discovering the True Dignity of Women." The title was based on the words of the Blessed Mother in the first chapter of Luke's Gospel. The conference featured women speakers—all of us in our 40s, all of us raised in the feminist "I am woman, hear me roar" era. We were asked to speak about how God has worked in our lives.

I found it fascinating that each speaker bought into this feminist mentality and we all ended up in the same miserable place. We all had success, money and prestige, but we had suppressed our womanhood in order to get ahead and had suffered the consequences. We were all stressed and stretched and believed that having choices meant we had to choose everything. We had to be superwomen.

Now, each of us is concentrating less on ourselves and more on our marriages, families and helping other people, and we are finally at peace with being the women God intended us to be.

It doesn't mean that we don't have careers or an identity outside of the home. Being a woman means that we have finally learned that it's okay to want to devote more time to your family or even walk away from a career. It means having real choices and not being forced to live up to someone else's

expectations. Being a woman means being yourself and giving of yourself. —Teresa Tomeo

Teresa is a former Detroit-area newscaster who now works as a professional speaker, Catholic talk show host and newspaper columnist. Her talk show can be heard on WDEO AM 990 and on the Internet at www.aviamariaradio.net.

It Was Said...
Let us then, be up and doing. With a heart for any fate;
Still achieving, still pursuing, Learn to labor and to wait."
—Henry Wadsworth Longfellow

Defining a Woman Today...
Promise, potential, possibility, and I find this incredibly exciting. The less than exciting part is in knowing that not all women will fulfill their promise. But I can hope that every woman I come in contact with, either through my speeches, books, or even sometimes brief but memorable interactions, will walk away with a slightly clearer sense of her potential while feeling more inspired to reach for it. —C. Leslie Charles

Leslie is a professional speaker and author of several books including, *All Is Not Lost* and *Why Is Everyone So Cranky?*

Did You Know...
That Frank Capra/James Stewart collaboration was largely ignored by the movie watching public until 1973 when a clerical error allowed it to slip into public domain status and the television networks re-ran it virtually for free. It was then that it was discovered and categorized as the "quintessential holiday movie." Its message applies year-round: *It's A Wonderful Life.*

Defining a Woman Today...
We all have choices. I made my choices, because I had to experience what I did, in order get where I am today. I grew up thinking all women had to be gorgeous, in order to be accepted. As a childhood actress, I grew up around movie stars. I think I needed to learn an important lesson: that it is not what is on the outside, but it is what comes from within. It is in the heart where you find the real beauty of a woman. I had to learn that substance was more important than what you see.
—Karolyn Grimes

Millions of people share Christmas with Karolyn every year. She is in their living rooms as ·ZuZu in the film, *It's a Wonderful Life*. She left Hollywood at 15 years old when she became an orphan and ward of the court. She finished high school in Missouri, married, had children and became a medical technologist.

My Final Thoughts...

I am now answering the same question I have posed to so many women. To me, being a woman today means being comfortable in my own skin. It means there are times I can be sexy and sensual. There are times I can be witty and sharp.

There are times I am hard working, yet fun. I am not defined by society's image or expected roles. I have learned from this journey that I don't need validation. I thought I needed to know the answers to these questions, because I would learn to mold myself by how other women defined themselves. But, I validate me. That is what this journey has taught me. I define myself.

I knew I had become a woman the moment I learned to accept myself for who I am. My dad taught me that and I finally got it on the day he died. I can't compare myself to other people. God gave me, like you, many gifts and I must use what I have to become the woman I want to be.

We all make our mark in life. My dad did. He touched so

many lives. I didn't know this until the funeral, when nearly 5,000 people came to pay their respects to a man whose name was never on a marquee or in a paper except in the obituaries, and who died not rich or famous.

I set out on this journey to find out when I would finally become a woman, and all along, the person who would teach me that very lesson was the man who raised me. And, it wasn't until he was no longer on this earth that I understood what he was trying to tell me. I can only pray that I might elevate myself to the human being he was and teach other people the great lessons he taught me.

Being a woman today means rising above the pettiness, the gossip, the jealousies and the insecurities, and giving back goodness. It was how my dad lived his life.

The images of what I thought a woman was or should be influenced my definition, but they didn't define me. My mother, my grandmother, my aunts, my teachers, my sisters, nuns and movie stars were all pieces to the puzzle that made up the picture of womanhood.

I am a woman, with all my faults and all my strengths. Now that I know I have certainly become a woman, I am on a quest to find the answer to the next question, which I've been asking myself since the 10th grade: How will I make my mark in life? It was Ms. Carolyn Witte, my English teacher, who put that thought in my head and it has never left.

Thanks for accompanying me on this walk throughout my childhood and young adulthood. I hope you form your own "SitChat" with friends and family and go through the journey with them.

I am like a little pencil in God's hand. He does the writing.
The Pencil has nothing to do with it. —**Mother Teresa**

How would you define being a woman today...

Forming Your Own "SitChat"

I'm just like you. I'm a woman in progress. —**Oprah Winfrey**

You now understand that this book serves as a tool, much like a guide to writing a journal. I want to help you form your own "SitChat" groups—similar to a book club—through which women can meet on a regular basis and talk about what it means to be a woman, or other topics.

I ventured into this personal crusade to figure out how and when I would feel like a woman, despite the fact that all forms of physical nature told me I was one. In order for me to truly understand my adulthood, I needed to understand my family and my upbringing, and I did that.

When I started to write this book, I debated whether or not to include my own story; then I realized it was because of my own experiences that I took on this project. I wanted to give something back. Therefore, I write this to honor my parents who discouraged gossip in our home. Instead, they wanted my six sisters and me to focus on how to better our lives.

Gossip is an easy conversation to fall into and often hard to rise above. There are people who are irritating, arrogant, rude, malicious and evil. Somehow, verbally ripping them apart is gratifying, but once you comprehend how cheap the dialogue is, you find yourself walking away from the group. Always remember that gossip doesn't promote growth; it muddles the mind and hardens the heart.

Instead of gossiping, we talked about life in the Denha

house. My favorite day of the week has always been Sunday because we gather as a family. When I was younger, it was Sunday morning before church. My parents and older sisters would drink coffee as we sat around the family room talking about how our week went. We often had family meetings to discuss serious issues. As we grew older and eventually moved out of the house, Sunday mornings together turned into Sunday dinners, and we continue the tradition today.

Out of my family experiences, I wanted this book to be about women participating in worthwhile conversations and transcending everyday chitchat into meaningful talk. I want women to form groups much like a support group, which I call a "SitChat," and I want them to start discussing the questions posed in this book.

This book can direct you into conversation with people you may have difficulty talking to. Some women don't know how to hold a meaningful conversation with their daughters, for example. I hope these questions can prompt a lifetime of friendships. These are stories written in the voice of each woman who participated. She speaks in her own tone and in her own words. I wanted you, the reader, to feel like you were sitting with these women and having your own "SitChat" as they told their stories. Then you can form your "SitChat" with friends, coworkers or family members and tell your own story.

We must rise above petty talk and engage in meaningful conversation that will change lives and mold respectable characters. We must also be supporters of one another. The old saying goes that behind every great man is a great woman. I think behind every great person is another great person.

I had my dad, my mom and my sisters. I want every person to stand behind someone else and push her along to find greatness in this world. That is what forming a "SitChat" is about.

How to form your own "SitChat":

1. Send out an invitation: Please join me for a "SitChat" to talk about *I Knew I Was A Woman When...* 5 to 8 women in the group is ideal.

2. Send the invitation out at least three weeks in advance.

3. Gather at a bookstore, coffee shop or host the chat at your house.

4. Ask each woman to bring a new journal.

5. As the host, you can use this book as your guide. Read from it. You don't have to be a support group leader or ever have had done this before. The book will be your teacher.

6. Set a time of about one hour to one hour and half for the "SitChat."

7. Have the women mingle for at least 15 minutes before you start talking. This will allow the women to open up more freely during the "SitChat."

8. Explain what a "SitChat" is and what you will be discussing. You should only get through the first question: What was the moment you felt like you had become a woman? Discuss it at this meeting. Or, you might have each woman go home and think about that question and prepare an answer for the next time you meet. After you discuss that question, at the following meeting, you can move on to the next question: Growing up, as a little girl, what was the image you had of what a woman was or should be? The third question can

be answered at another meeting: How would you define being a woman today?

9. Each woman is given 10 to 15 minutes to answer the question—the time can be divided equally among the number of women in the group.

10. At the end of the "SitChat," allow 10 to 15 minutes for open discussion.

11. Once you discuss all three questions, you can continue your meetings by talking about women in history, and how each woman made an impact. Or, you can take turns talking about women you think young girls today can emulate. Another topic can be on a current event issue and how it impacts our everyday lives. Keep the discussions going until the next book in the "SitChat" series is published.

12. Keep your "SitChat" journal as you journey through life and one day it can serve as a guide to young girls emerging into womanhood.

Bibliography

Books and Literature

Women's World, A Timeline of Women in History, Irene M. Franck & David M. Brownstone (Harper Collins, 1999)

The Detroit Science Center, press release, August 26, 2002, "Jane Goodall Swings into the New Detroit Science Center On Saturday, Oct. 12"

The Book of Positive Quotations, compiled and arranged by John Cook (Rubicon Press, Inc., 1993)

Television

Lifetime Television, "Intimate Portrait: Elizabeth Dole," aired May 12, 2001

Lifetime Television, "Intimate Portrait: Roma Downey," aired in 2001

Lifetime Television, "Intimate Portrait: Cindy Lauper," aired 2002

Lifetime Television, "Intimate Portrait: Star Jones," aired in May 2001

Magazines

Us Weekly, April 23, 2001, quote from Camryn Manheim pg 32

People Weekly, April 30, 2001, quote from Suzanne Somers pg 81

In Style Magazine, December 2000, quote from Duchess of York Sarah Ferguson, pg 570

People Weekly, July 16, 2001, quote from Oprah Winfrey, pg 3 (speaking in Raleigh, N.C. to fans on her motivational tour in 2001)

Time, March 8, 1999, information on Gertrude Elion, pg 27

Time, March 8, 1999, The American Heart Association, statistics on women and heart attacks, pg.72

Time, March 8, 1999 pg 64 (Women replace heels for sneakers)

Time, March 8, 1999 pg 62 (Women's Health Network) and gynecological self-exams

Websites

ESPN.COM, Didrikson was a woman ahead of her time, Larry Schwartz
http://www.edessa.com/women/margaret.htm, Assyrian Information Medium Exchange The Assyrian Woman on Margaret George

www.destinationhollywood.com/movies/iawl/- Destination Hollywood- *It's a Wonderful Life*
www.theresemovie.com/en/reallife/mainframe_reallife.html

www.catholic-forum.com/saints/saintt02.htm

www.web.simmons.edu/~lacey/mpbh.story.html
(women's professional baseball history page)

www.webaccess.net/~coolclas/harriet.htm

www.womeninmedicine.com

www.nwhp.org/whm/themes/themes.html

www.undelete.org/military/lives.html

www.undelete.org/military/spies.html

www.undelete.org/military/prisoners.html

www.undelete.org/military/miltv.html

www.undelete.org/military/astronaunts.html

www.undelete.org/military/timeline1.html

www.cmongethappy.com, *Partridge Family* facts

Endorsements

"When was the exact moment you felt fully female? For some women, it was the first time their boyfriend trembled with excitement and passion. For others, it was the first time they looked in the mirror and realized they were beautiful. For others, it was the first time they nursed their newborn child. This fascinating book explores this thought-provoking topic and provides a forum for women to share a revealing and rewarding dialogue on an issue we should all discuss with our mothers, sisters, daughters, and friends. Read it and reap." **Sam Horn, author of *Tongue Fu!* and *What's Holding You Back?***

"Vanessa Denha has asked the questions we all need to ask ourselves. At what point did we really become a woman? What made us 'grow up'? The book was a great idea, and is a great read for all women, as well as men. Once we truly accept our 'womanhood,' we can then continue our journey into 'super womanhood.' Vanessa marks the beginning of this journey of reflection and growth." **Chrissie Blaze, author of four books, including *Workout for the Soul: 8 Steps to Inner Fitness*, Aslan, 2001, astrologer, international lecturer and media guest.**

"We women today are being pulled in sixteen different directions. Whether it's commitments on the job, at home, or both, we are constantly on the fast tract and rarely stop to reflect or to reprioritize. Vanessa's book is chance for every woman to do just that." **Teresa Tomeo, Professional Speaker/ Catholic Radio Talk Show Host**

"Touching. Inspiring. Unforgettable. These words come to mind after reading Vanessa Denha's *I Knew I Was a Woman When...* This sensitively written blend of personal observations and insights with an historical perspective makes a perfect gift for a daughter or granddaughter coming of age, or a bosom buddy who shares your interest in our gender's history and future." **—C. Leslie Charles, author of *All Is Not Lost* and *Why Is Everyone So Cranky?***

181

Printed in the United States
18592LVS00002B/178-357